Folk Art Cards

First published in 1993 by
Sally Milner Publishing Pty Ltd
558 Darling Street
Rozelle NSW 2039
Australia

© Joyce Spencer, 1993

Design by Gatya Kelly, Doric Order
Photography by Rodney Weidland
Typeset in Australia by Asset Typesetting Pty Ltd
Printed in Australia by Impact Printing, Melbourne

National Library of Australia
Cataloguing-in-Publication data:

Spencer, Joyce.
 Folk art cards.

 ISBN 1 86351 109 1.

 1. Greeting cards. 2. Folk art. I. Title.
 (Series : Milner craft series)

745.5941

MILNER CRAFT SERIES

Folk Art Cards

JOYCE SPENCER

SALLY MILNER PUBLISHING

By the same author

The Art of Teaching Craft by Joyce Spencer and Deborah Kneen, Sally Milner Publishing, 1993.

Copyright

ACKNOWLEDGEMENTS

*T*hank you to the many people who gave me encouragement and support: to my husband Geoff; to Deborah Kneen; Sally Milner and Margaret Masters. Also, to my painting friends for offers of typing, lending items for the cover and poems. Their spontaneous reactions when shown the ideas for painting cards was very heartening. And to my granddaughter Ashleigh, who is my painting friend, student and unbiased critic, and loves everything I paint; to the management and staff of Alderson's, craft and art suppliers, at Kogarah; to the early folk painters, ordinary people, whose innovative techniques, skills and quality of work, has survived to encourage people like me with little formal art training to take up a brush and paint.

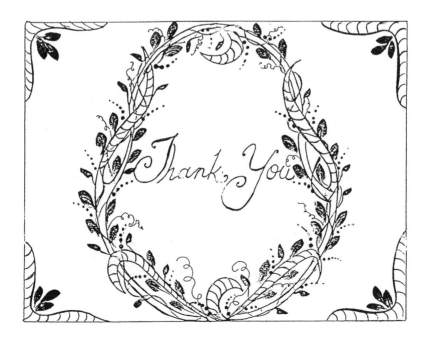

PROFILE

I discovered Folk Art painting later in my life, or perhaps it found me. Studying wherever I could find a teacher, I eventually introduced classes into my craft shop. This was just the beginning.

Painting in both the traditional and decorative manner has brought me great joy and many friends. It is a never-ending process of discovery and learning.

When Jo Sonja Jansen first visited Australia, I had the honour to attend her three-day seminar in Canberra. It was there that I met many talented painters. We continue to meet, paint and have fun at an annual retreat in Mittagong, NSW.

The Sydney painters who attended the seminar decided to meet and paint together once a month. This event has grown from small beginnings in my home, to a hall in Kogarah Bay. It is a wonderful experience to paint in friendship, and I value my membership of the Folk and Decorative Artists' Association of Australia.

I love all styles of painting and will paint virtually anything. I feel a need to paint, or prepare an article to paint, every day, if I can. There is something about Folk Art that touches my soul.

I cannot imagine my world without painting. I know that this joy is shared by others who learn this method of painting. The caring and sharing of knowledge, the warmth and generosity of the many people I have met, have made the sun shine brighter.

Joyce Spencer

CONTENTS

FOREWORD

Make little gifts and keep friendship alive.

Old French Proverb

The craft of handmade greeting cards reached its peak in the Victorian era. In modern times, however, this gentle art has almost been lost in a maelstrom of commercialism and mass production.

In *Folk Art Cards*, Joyce Spencer keeps the old traditions alive by sharing with us her wonderful ideas for creating personalised Folk Art messages. Having been the lucky recipient of several of Joyce's painted cards, I know how truly special these keepsakes are. Once you become involved in this craft, your family and friends will also experience the delight of receiving unique cards, handcrafted from the heart.

A creative and inspiring craftswoman and teacher, Joyce will soon have you caught up in the adventure of card-making. For folk artists, this has been, up to now, a relatively uncharted area but one full of potential, as you will soon discover. The beautiful illustrations and lively instructions, packed with useful hints, will tempt painters of all levels.

Joyce brings her many talents to bear in this book. Although well known for her innovative Folk Art and faux finishes, she is also a fine writer and poet. The text of *Folk Art Cards* reflects the wit, flair and enthusiasm which typify the lady herself.

It gives me the greatest pleasure to introduce this book to you. Joyce presents exciting new avenues for folk artists to explore and inspires us all to communicate with each other in a more personal and caring way.

Deborah Kneen, Sydney 1993

INTRODUCTION

*T*his book is about painting on watercolour paper, using folk and decorative techniques, to make unique greeting and gift cards. Painting on paper is no different from working on other traditional paint surfaces. The same strokes are used and base-coating, sponging, tracing, marbling, crackling and all the many techniques available are possible. The paper I use is made in Australia from linen and cotton rag.

Throughout the book, interesting historical information is given, along with verses, old sayings, hints and ideas. Some of the illustrated cards demonstrate the use of gold leaf, glitter, pearlised and metallic paints. These are all fascinating surface effects which enhance the cards.

Books of old greeting cards, picture postcards and early graphic images are a source of inspiration. The fine drawings, floral designs, alphabets and motifs of the Victorian and Art Nouveau periods are available for us to use today. Some are copyright free, others are for personal use only.

In the past, many cards were handpainted with lyrical messages, scenery and flowers, and were embellished with scrolls and copper-plate writing. Thankfully, many were stored in lavender-scented drawers, pressed flowers scattered among them, and tied with ribbon. These antique cards are precious keepsakes.

Think how popular you will be when family and friends receive individual, handpainted cards from you, whatever the occasion. They will become collectible treasures.

This pastime is an inexpensive and happy one. If you already paint, then please use your own designs and style.

If you have never held a brush, take heart. By following the step-by-step instructions, methods and techniques, and choosing a sponged or spattered background to start, you will soon gain confidence and develop new skills.

It is my hope that, with patience and practice, you will be totally caught up in the spirit of making Folk Art cards. Be sure to express your individuality and put your unique stamp on them.

HOW TO USE THIS BOOK TO PAINT CARDS

*T*he aim of this book is to get you painting freely as soon as possible. Trace at first, by all means, because Folk Art is an expressive style of painting, and the more you trace, the better you will be able to work freehand from memory later. Choose what you would like to paint and which colours, shapes, techniques and arrangements you prefer. Colour, especially, is a very personal matter. We are all attuned differently to it, as our homes and dress reflect. No two of us are alike.

For experienced painters, the book will inspire you, I hope, to paint your own designs, or those of other artists who give their permission, using some of the ideas shown here. All the designs and working methods are interchangeable.

If you are painting for the first time, please read the book through carefully, and note the equipment necessary for your first card. The shopping list becomes more sophisticated as you read on, the cards progressing from a simple sponging technique to more advanced skills.

A quick glance down the instructions for each card will show that they are easy to read and understand. First choose the card you are going to paint and set out your equipment. After basecoating or preparing the card for the chosen finish, trace the design or paint it freely using the step-by-step colour guide.

The details and painting guide for my own Light Airy Fairy Style (LAFS) are written for the card of that name and are included on other cards where stated.

Suggestions are given for a suitable envelope or message.

Try not to be nervous — we all had to start somewhere. I certainly did not wake up one morning to find myself a Folk Artist.

LIST OF EQUIPMENT

*S*ome of these requirements are found around the house, others need to be purchased from art, folk art, stationery, and craft shops. It is not necessary to buy everything at once; the items can be purchased as needed.

General needs

cotton buds	glue	disposable gloves
an old towel	ruler	foam trays, lids
Blu-Tack	notebook	cardboard
an old toothbrush	scrap paper	cardboard rolls
tooth-picks	Magic tape	small water jar
pencil	soap	cotton balls
sponges	saucers	cotton gloves
plastic film	scissors	feathers
plastic bags	detergent	greaseproof paper
tweezers	nail brush	pen

Art supplies

BRUSHES

- 1" foam or ½" hair applicator brush
- No. 4 round
- ⅛" dagger brush
- Roymac CS-23-6 Shader
- 1 Script Liner
- mop or make-up brush
- small stencil

PENS AND PENCILS

- Artline Drawing system, permanent and waterproof ink, size 0.1
- White carbothello pencil

PAPER
- Arches Watercolour Pads. 300 gsm. ref. APS 021, Hot pressed. Yellow Cover 15 sheets
- Paper for envelopes — Foolscap size, Recycled pads, Canson, Calligraphy, Cartridge, Brown. Refer to *Envelopes* (page 38)

FINISH
- Duncan G.S. Sand 238

GOLD LEAF
- Pads of 25 sheets, often called Dutch Metal

GLITTER AND POWDERS
- Small vials

DIMENSIONAL PAINTS
- Gold, Silver

TRACING PAPER
- 1 sheet each blue and white Saral paper

KNEADABLE ERASER

STENCILS
- Plaid emboss and stencil
- Helex letters

MASK 'N PEEL
- Duncan

EMBOSSING TOOL

PAINT MEDIUM
- Jo Sonja's: Crackle, Kleister, Tannin Blocking Sealer, Clear Glazing, Antiquing and Retarder and Flow.
- Duncan: Quick Crackle.

VARNISH

- Jo Sonja's water-based varnish

PAINTS

- Folk Art: Basecoats-Tapioca, Liquorice, Blue Bonnet
 Metallics — Rose Shimmer, Blue Sapphire,
 Aquamarine
- Jo Sonja's: Warm White, Titanium White, Pearl
 White, Turners Yellow, Yellow Light, Carbon Black,
 Burgundy Plum Pink, Napthol Crimson, Moss Green,
 Pthalo Green, Green Oxide, Pine Green, Sapphire,
 Ultramarine Blue, Storm Blue, Rich and Pale Gold,
 Silver, Gold Oxide, Norwegian Orange, Teal Green,
 Trans Magenta, Brown Earth, Raw Umber

LETTERING

*L*ettering is an art form. Many beautiful letters and characters have been handed down to us through the ages. Alphabets come in all shapes and sizes; Early Roman, Gothic, Old English, Victorian, Art Nouveau, Art Deco, the classic Bauhaus Outline, Palace Script and Egyptian are just a few styles.

If you have learnt calligraphy, then you will have no problems inscribing your cards with a message. For those whose handwriting leaves a lot to be desired, the illustrated messages will be most helpful. The captions can be traced, then painted.

A large capital letter, decorated and embossed, can look splendid in the centre of the card. The liner brush is a good tool for this work. Thin the paint with a little flow medium; two coats of paint may be needed. Black, gold, white and brown are good colours for letters.

Calligraphy pens are useful. So are the dimensional paints, iridescent and glitter paints. They have very fine plastic tips which act as a pen. Refer to card *Rose on Moss-covered Sandstone Wall* (page 54).

If you have a favourite alphabet you want to use, you may have to reduce the capitals or lower case to fit your greeting into the space. This means drawing pencil lines, tracing and spacing the letters on to the card. Finally, you can apply the paint. The use of fine-point waterproof pens is mentioned under Pen and Wash (see page 27). Embossing and stencilling techniques are also discussed (see page 25).

Odd sayings, verses and religious messages are all appropriate. Libraries are a good source for these. Adapt the words to your own use, writing them in a simple script, or illuminating and painting them.

Spare a thought for the early scribes and illuminators, living in monasteries, who painted and wrote on vellum, illustrating the subject of a religious or philosophical text. As printing methods became mechanised and colour photography and printing were developed, they were utilised as a means of mass communication. But the pleasure and inspiration one can draw from a more personalised approach, still endures.

In Victorian and Edwardian times, travellers in Europe, wishing to send news of their whereabouts to family and friends, often handpainted cards depicting the scenery. This early means of communication, and the introduction of a cheap postal charge, saw the

emergence of greeting and message cards, called postcards, in numerous countries. The method of delivery was by coach, train, boat or by hand.

Thankfully, many cards have survived because of the interest of early collectors. Antique shops still sell many of these cards for a few dollars. Many were velvet flocked, embossed, sprinkled with glitter; all are a joy to read. You may care to start an inspiring collection.

I hope in some small way, that you and other Folk artists will revive and personalise this means of communication, using your own style of painting on watercolour paper cards.

WATERCOLOUR PAPER

*W*atercolour paper is made from linen and cotton rags; this means no trees are lost in its production. The paper is made into large sheets then cut into pads of different sizes. I have chosen the Arches Watercolour Paper Pad comprising 15 card-size sheets. After being removed from the mould, the paper is rolled on hot presses — hence, it is known as hot-pressed. This gives the surface a fine texture. The sheet size is 135 mm x 180 mm, the weight is 300 gsm.

When you become more familiar with working on paper, there are other papers and textures to experiment with, in larger sheets and pads. Cold-pressed paper is removed from the mould and then rolled on cold rollers; this gives the surface a rougher texture which lends the paper more character.

If you like to paint small designs and work in postcard size, the sheets may be cut in half. The full sheet can be folded for gift cards, and cut to size and shape for gift tags. Never discard scraps of this paper, painted or otherwise. They are useful for tags and stickers, pasted on the flaps of envelopes, and on gifts.

The paper has a gelatine-sized surface. This is the right side. Use a small pencilled tick to remind you which side it is. The larger sheets have a watermark which can be seen when the paper is held up to the light. However, if the paper is cut to card size, mark the right side with a tick. Please note that the pad sheets do not have a watermark.

Paper has a long and interesting history. The best papers are made from linen and are often handmade, the product of highly skilled workers. Rice paper is thinner. Made from vegetable fibres, it is better suited to delicate painting. The established painter can treat paper surfaces in the same way as wood. They can be crackled, lightly sanded, embossed, varnished, gold leafed and antiqued. All instructions are given for these techniques. Have fun; experiment. Paper is cheaper than wood or metal and occupies less space.

LEARNING TO PAINT

Setting-up

*F*inding a suitable place to paint is important. Table and chair heights should be compatible, or a cushion may be needed. I paint at the kitchen counter, seated on a stool where I can rest my feet. The light falls across my work at the right angle. I am near the phone, the sink, and a power point for my directional light. The counter is covered with an old towel. Don't use newsprint because it will rub off on the paper.

The paints and brushes I need are set out on my left. My book is in a clear plastic recipe-book holder in front of me. My palette is a saucer covered with plastic wrap, rolled back. If the phone rings, the wrap is pulled over my paints to prevent them drying out.

To my right is my palette, a small jar of water, cotton buds, a sheet of paper towel folded into four, for better absorbency, and folded greaseproof paper if my work involves blending.

Some people are blessed with studios and work in air-conditioned comfort. However, there are many people not so fortunate, living in small places. Once you become a card painter, for pleasure or profit, space is not a problem.

Remember a creative mess is better than tidy idleness.

CLASSES

*M*ost people are close to shops or teaching studios where Folk Art is taught. For those who cannot reach these services, there are videos, library resources and even visiting tutors. In my area, for example, there are several Church craft groups teaching Folk Art.

Often, you may be unaware that someone nearby is also a painter. Groups are forming everywhere; scan your local papers for details or place an advertisement yourself if you are looking for fellow enthusiasts.

Craft magazines have excellent directories of suppliers. Folk Art and art suppliers are listed in the Yellow Pages, and all welcome mail order enquiries.

BASECOATING

*T*here are two types of basecoat. One is the overall main colour or foundation on which you will work. It may require more than one coat. The second basecoat is applied to the actual traced design. Leaves, flowers or letters must be basecoated. This, of course, involves other secondary colours. Two coats may be needed.

Try to avoid making ridges. These are caused by applying paint too thickly. Avoid this by thinning it with a little varnish, water, retarder or flow medium. Take particular care not to overload when painting the design with smaller brushes. The weather is another factor to take into account because heat and cold can affect the way in which the paint 'performs'. Drying can be hastened with a hair dryer, but only use a low setting of heat and air.

I have a small plastic tray on which I have placed strips of Blu-Tack the length of the cards. This raises the working surface of the cards and prevents bleeding underneath. Masking the edges on the underside of the cards with Magic tape also prevents bleeding. Take care to watch for excess paint near the edges of your work and remove the tape as soon as possible if paint is in danger of leaking under it. Keep working surfaces clean at all times. Don't worry if at first leaks occur. Blobs can be turned into flowers or borders. If all else fails, trim the paper down and use as gift cards or tags (see page 70).

The Plaid Folk Art product is my first choice for basecoating. I prefer Jo Sonja's products for the stroke and other painting, unless I have stated otherwise. The selection of a paint brand, ultimately, is up to you. I like to try them all; most can be intermixed.

We all paint differently; some have a lighter or heavier touch, but the basecoat must always be correctly applied. Practising on scrap paper is a good way to start. Keep these scraps as they will be useful for testing colours of basecoats and colours on top of basecoats.

Specially prepared basecoats are available, but the colour range is not as wide as ordinary Folk Art paints. However, the quantity is greater, which is good if painting dozens of wedding invitations, for example. Metallic and pearlised paints are wonderful for basecoating the cards; they make them glow.

METHOD

1. Prepare and mask card on tray or clean surface.

2. Wring out applicator brush in water.

3. Pour paint directly onto brush or place on a small palette.

4. Paint with long, careful strokes, watching edges and ridges. It is better to apply two thinner coats than one thick one.

5. Pick up more paint or remove excess.

6. Allow paint to dry thoroughly between coats.

7. Cut and trace template if necessary.

8. Apply second colour if it is required as part of the design.

You are now ready to paint and trace the design. Or, use this basecoat as the foundation for another technique such as crackling.

Hard work never hurt anyone, and why take chances?

BRUSHES AND BRUSH CARE

*H*andling the brush for the first time can be quite daunting. We wonder how we will perform, and how we can obtain the desired results from such an implement. I tend to be a compulsive brush buyer and I do have favourites. Let's look at a brush. It has a painted wooden handle on which are given details of the size, the type of bristle, the manufacturer, the brand name and a series number. All Folk Art brushes have shorter handles than traditional oil-paint brushes. The bristles are encased in a metal ferrule, round or flat, attached to the handle; hence you have a choice of a round or flat brush. The bristles can be natural, synthetic or a mixture of both. They can be long or short, or angled like the dagger brush.

The larger we paint, the bigger the brush; the smaller we paint, the finer the brush.

Care for your brushes. Soap and water are good, as are proprietary cleaners and brush basins from art shops. Soap them gently, swish them through the water and pat dry. If the water is coloured, then paint still remains in the brush. Re-wash. Never leave paint in your brush or leave the bristle end standing in water; the hairs will bend, never to straighten.

For card painting, we will start with four brushes plus a foam applicator brush. These can be increased or decreased in size when you feel more familiar with brush usage and styles. Once you have set up your painting space, you are ready to start learning and practising strokes.

STROKE PAINTING

*F*olk painting in the traditional way requires the mastery of strokes relating to a specific style. Every country's style differs and we could spend a lifetime studying just one of them. In Europe, for example, the Dutch style is known as Hinderloopen. In Norway, the style is Rosemaling. In Germany, the Bavarian peasant painting is referred to as Bauernmalerei. Countries such as Russia, France, England and Italy and many others also developed distinctive styles. I urge you to read the many books available on these subjects. Our contemporary style is just emerging. We have safer, better paints and equipment today, but we still respect the established traditions.

A round brush is needed to work a 'comma', a stroke synonymous with the Bavarian style. It can be used in rows to form a border. Or, it can be worked in two or more colours on a basecoated shape to represent flowers or leaves, or to form some other decorative shape.

Originally, artists had to learn to paint the stroke in all directions, especially when working on large furniture pieces and on beams and ceilings. Painting and embellishment was done in situ, but we have things a lot easier and can turn our cards around to facilitate the working of simple 'commas'. Set up ready to practise.

Comma Stroke (*Round Brush*)

METHOD

1. Squeeze a small amount of paint onto the palette.

2. Dip brush in water. Take a small amount of paint and mix with water on the palette. (For practice strokes and painting on paper, the paint needs to be thinner.) Load or take up paint into the brush.

3. Hold brush upright in a pencil grip.

4. Support hand on little finger. You are going to gently roll your hand in the direction of the stroke. To the right, left, up and down.

5. On scrap paper, place the tip of the brush down, applying pressure. Notice that the bristles spread out. Lift off. Place tip of brush down on the paper without pressure, and make a line. Notice the fine line. It is this combination of applying and releasing pressure, then curving the stroke in the direction you want it to go, that makes good strokes.

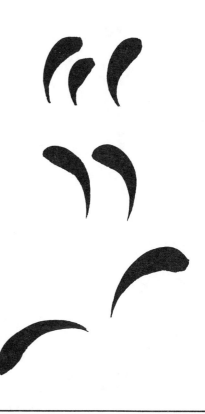

6. Do not lift your hand until the stroke is completed.

7. Re-load your brush with more paint. Remember, for thick lines, apply pressure; Thin lines, no pressure.

It is quite normal to mutter 'blob, lift and pull' while learning to stroke paint. Lift the pressure off, not your hand.

Strokes vary from person to person. Some painters are better stroke-makers to the right, or left, up or down. We need, however, to practise hundreds of them. Make every stroke count. Look at your brush, check the paint, and mutter to yourself. Do not be modest. Always tell yourself how clever you are.

I was very slow at first; my first attempt was awful. I keep my first painted piece as a reminder of my introduction to stroke design and to traditional folk art.

'S' Stroke *(Round Brush)*

METHOD

1. Load brush with paint.

2. The stroke begins with no pressure and a slight curve, then pressure. Release pressure ending with a curved line or tail.

3. Practise strokes in all directions.

4. Double load all strokes.

When completed, the strokes look like penguins because of the straight line through the 'S'. If you cannot get the angle of the stroke correct, it is a good idea to draw in some pencil lines for guidance and to paint over the top.

The Hinderloopen style of painting uses the full 'S'. The stroke and the alternating pressure are utilised to great advantage when working lovely ribbons and bows, leaves and tulip petals.

I find that I have to concentrate when I am doing these strokes, when double loading and decorating. When switching from stroke to stroke, the amount of paint on the brush has to be checked with every stroke. Every stroke should count and make a strong statement.

BOWS

The secret to doing good bows is to work away from you, even holding your work in front of you. Load brush loosely, with two or more colours. Paint the stroke down with pressure, turn, come up with no pressure. Down pressure; up, no pressure; down and pressure, then no pressure for a fine line to finish.

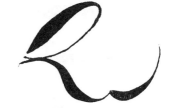

Liner Work (Liner Brush)

METHOD

1. Mix paint to a thinner consistency than usual with brush.
2. Remove excess paint onto paper towel.
3. Roll tip of brush round and round in paint.
4. With a very light touch, paint and draw fine lines with this brush.
5. Practise squiggles, your name, cross-hatching and strokes.
6. Practise double loading with this brush (see below).
7. Add a few drops of Flow medium. Note the difference.

The script liner brush has longer hairs and is smaller in size. This means that the paint has to be thinner for the long bristles to go round and up and down and in and out. Thick paint will not do this.

The addition of J.S. Flow Medium helps achieve the consistency. The density of the colour is not altered.

You will find liner work scattered throughout the cards. In time, you will recognise all the strokes and the styles of painting. All the trails are done with this brush in my style of painting referred to in future as LAFS: Light Airy Fairy Style (see page 62 and plate 5).

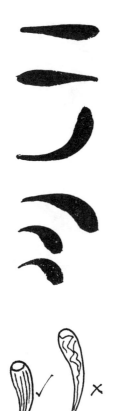

correct incorrect

Double Loading *(Round Brush Tipping)*

METHOD

1. Put two contrasting colours on palette such as Warm White and Pine Green.
2. Pick up main colour (Pine Green) on brush. Tip into Warm White. Remove any excess.
3. Paint comma strokes. Note the white on top and a stripe as you pull down the stroke. Reverse colours. Try gold and other metallic paint. Try 'S' strokes and use the liner brush.
4. Do not wobble the brush, or the stripe will be wobbly.
5. Load brush for every stroke. Wash brush when changing to another colour.

This technique is unique. It is a means of applying light, shadow and highlight to beautify and give depth to the flower, leaf or shape to be painted. On a leaf for instance, half could be stroked with green tipped with white. The other half could be a darker green, tipped into a lighter green for the shadow. A very light tip into a metallic paint such as gold is stunning.

Dagger Brush

METHOD

1. This is very useful for leaves. Place one, two or three colours close together on the palette.
2. Dip brush in water, pat into paint, or paints, very lightly. The paint for the background leaves needs to be washy, the stroke very light. For foreground leaves, the paint must be streaked more with colour and more pressure is required on the stroke.
3. With a light touch and the brush held vertically, make a stroke; it should be a dash (which is good for ferns).
4. Place the brush down again, pull it over to the left and stop. Lift to the right and stop. Lift. There should be a tiny tail, eliminating the need to pull the brush down any further.
5. Paint leaves in groups.
6. Wash brush carefully after use.

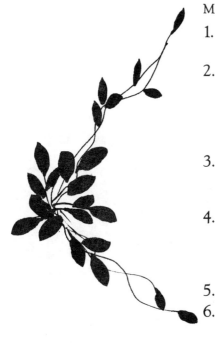

I always keep these brushes when worn out because the hairs spread out giving a fuller petal or fern leaf than a newer brush will do.

This little brush is a treasure. It differs from an angle brush in that the dagger angle is more acute; hence, the necessity to carefully clean around the metal ferrule after use.

Once you have mastered using the dagger brush, strokes can be worked easily to form leaves on the trails of LAFS. Quite large leaves can be made with pressure and practice.

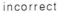

incorrect correct incorrect

Flat Brush

This brush is very versatile. It can be used for basecoating, stroke work, shading, highlighting and painting flowers, particularly roses.

Everyone wants to paint roses; there are innumerable examples of them in Folk Art. The blended rose is one of the hardest flowers to paint.

If you take the flat brush and blend in easy stages, you will have no trouble. You will need to paint dozens of roses before you fully understand the process. Note that for small roses and buds the brush must be small. Larger roses require a larger brush.

Blending (Flat Brush)

When blending, you need to be organised and to paint in an orderly manner.

MATERIALS

A water jar, containing a little water (which will need to be changed frequently) must be on your right. You

will also need a folded paper towel and folded greaseproof paper, a clean palette and cotton buds (optional).

METHOD

1. Squeeze paint onto palette like toothpaste on a toothbrush. Use two contrasting colours, say Warm White and Plum Pink.

2. Dip brush into water, pat gently each side on paper towel.

3. Turn your brush to one side and scoop up white paint on one corner. Flip brush over and scoop up pink paint on the other corner. Take paint from the end; do not contaminate the paint. If pink paint is left on the white for instance, you will need to pick up pure paint further along. More paint is used this way, but if the palette is held up closer to your face, you can better see what you are doing, and the brush is angled better. You are now going to blend on greaseproof paper.

4. Blend, backwards and forwards on a strip 2.5 cm (1″) long. Move up into the white; never take the white down to the pink. We need the white on top of the strokes for highlight.

5. Pick up more paint; white on white side, and pink on pink. Blend on another strip. Check tip of brush to see blended paint. A brush filled with paint and blended correctly goes a long way.

6. Practise some small buds. With the white on top and the brush on its side (which is the chisel edge), go up and slide over and down and stop. Lift brush. Place chisel edge on the left side, white paint up. Go down and over and up and stop. If you forget to put the white on top, the paint will blend. If that happens, wash brush and blend again. Look frequently at the paint on your brush.

7. To clean brush, swish it through the water. Pat on paper towel. If colour is still evident, then wash again and change the water.

8. Practise some strokes. Once you understand the process of blending, try the addition of retarder on the brush, either before or after you blend. It will help you work. Water can also be taken up into the paint-loaded brush, to thin the blend.

Please refer to the colour guide for further strokes and the rose shape which needs to be basecoated.

Blending (*Round Brush*)

Please refer to the colour guide before painting. We are going to blend some pink strawberries.

When blending with a round brush, the paint is picked up on the brush and applied to the basecoated shape. Different colours are dabbed on gently to create light, shadow and highlight.

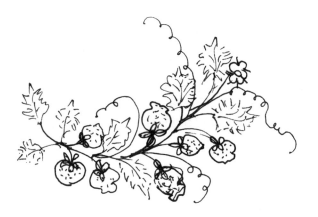

METHOD

1. Put Magenta, Warm White and Burgundy on the palette.

2. Basecoat some circles or strawberry shapes with Magenta.

3. When dry, make a small mix of Warm White and a little Magenta. Use a satay stick or knife to mix.

4. Wet brush, flatten out tip and pick up a small amount of this mix; apply paint on the left side of strawberry.

5. Wash brush.

6. Flatten tip and pick up small amount of Burgundy. Dab this gently on the right side.

7. Wash brush.

8. Flatten tip, pick up small amount of Magenta. Blend and dab gently all over from the light to the dark, removing the demarcation line.

9. Look closely. You should have a blended strawberry with light on the left and some shade on the right. Wash brush and dry.

10. To highlight, use a dry brush to pick up a whisper of Warm White. Lightly touch it on the left side at 10 o'clock. Wash brush. Refer to *Strawberries and Cream* (page 49).

This is an introduction to round brush blending. When you are comfortable with this technique, it is the time to experiment with colour. Leaves can be blended. Other colours such as red, yellow, blue and gold can all be put here and there and blended. For softer blending, retarder is useful, especially when painting ribbons.

I find this a very relaxing technique and devised this for beginners. More advanced painters will be more aware of the light and shadow placement.

Note: There is a brush carrier made from material which has little pockets for each brush. It's a very useful item to have when going to class.

TECHNIQUES OF FOLK ART

Medium

A medium is a specially formulated substance which assists our painting in many ways. Throughout the book, instructions and details are given for their recommended usage. I usually use Jo Sonja's product.

Paints

Paints today are acrylic and water-based. This makes for easier cleaning. They are safer to use than the earlier paints. They come in bottles and tubes. Some are pre-mixed and others need to be broken down with water to a workable consistency. The colour range is wide. The newer metallic and pearlised paints are used freely on the cards shown in this book.

My tastes are simple; I like the best.

Painting Style

Over a period of time you will develop a way of painting that is entirely your own. There is no particular time at which we discover this style; it seems to creep up on us through practising techniques and experiments with colours. You will know when the moment has arrived and feel good about it. Painting reflects your personality.

I believe that it is not until we are able to sit down quietly and paint more freely, drawing on all the information we have stored in our minds during the learning process that our style begins to emerge.

Tracing is useful, but, when you have traced the same pattern several times, perhaps you could try drawing it freehand just to see how much of the pattern you really need as a guide. We retain a lot in our minds especially when tracing a design repeatedly, then painting it. Try placing just a few circles here and there, to indicate flower shapes. This is a good way to start painting in a freer way.

My style of painting is fairly loose throughout this book. I call it my Light Airy Fairy Style and I am happy to share it with you. I feel as I look at my work that I am creating all the trails, leaves, filler flowers and roses in a free-flowing way. I love painting leaves with that little treasure of a dagger brush. Every painter should have one.

There is nothing more exciting than to hear the response from students: 'I'm painting, I am really painting.'

Sponging

Sponges come in a variety of textures and each one gives a different effect, particularly when more than two colours are applied on a card. There are natural marine sponges, synthetic silk sponges, household wipes, car sponges and make-up and ceramic sponges. All are useful.

The secret of sponging is not to press too hard and get blobs. A quick, light touch is best, drifting different colours across the surface. Pat, pat, pat. Lovely effects are obtained and colour combinations are endless. Happy sponge hunting.

To commence sponging I refer you to the *Simply Sponged* card (see page 42).

Old postcards had gold and silver backgrounds which added lustre and dimension to the surface. A little gold dust could be sprinkled on while the paint is wet. I keep mine in an old pepper shaker, clearly marked 'Gold Dust'. Off we go. The paints listed opposite were used for *Simply Sponged* card.

blob (heavy)

blob (light)

light blend

change colour

drifts

sea sponge

MATERIALS

Rich Gold, Pearl White and Pink Shimmer paints. Paper, plastic tray, sponges, water in basin, scrap paper, gloves.

METHOD

1. Mask edges.
2. Apply a basecoat if you want.
3. Space paints out on your palette.
4. Wring out sponge tightly in water.
5. Pick up one colour of paint on the sponge. Quickly and lightly dab it on the card. Turn sponge, pick up another colour and dab close to the other colour or just into it. Turn sponge, pick up the third colour and sponge, blending in closer, covering any gaps.
6. Look closely at the results. There should be some attractive colour values here. No glaring blobs; all the colours should be intermixed.
7. Wring out sponge and repeat the process until the result is pleasing.
8. When sponging the inner or outer shapes with templates, pressure needs to be applied to the template edge. This prevents bleeding of the paint underneath. Remove template quickly and remove any bleeding with a cotton bud should this happen. Refer to *Happy Birthday, Daisy* card (see page 74).

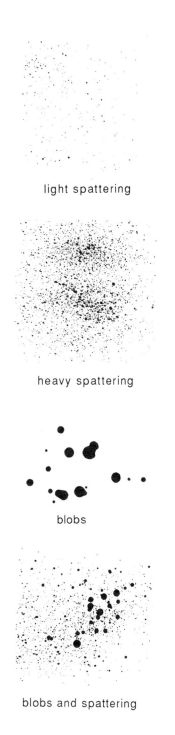

light spattering

heavy spattering

blobs

blobs and spattering

Spattering or Speckling

Folk painting brings us a whole new vocabulary, a very colourful one. Spattering is a delightful way to 'age' your work. The effect resembles fly specks, smoke, dust and borer holes. It can also be used to soften a painting and tie the whole design together. The spattering shows up well on the card *Flannel Flowers on Sepia Background* (see page 43).

METHOD

1. Cover area where spattering is to be done.
2. Mix colour required on a palette, using a toothbrush.

3. Thin paint with a little water if necessary.
4. Mask any areas on the card that are not to be speckled.
5. Wear a disposable glove. Tap off excess paint to prevent blobs. Practise on scrap paper first.
6. Holding the toothbrush away from you, flick the bristles with a knife or gloved finger. Pick up more paint if needed. A little of this can really go a long way, so be careful.
7. For very artistic and larger blobs, tap the handle with the handle of another brush. Place here and there on the card. Follow with spattering of another colour. The result will be striking.

Note: Little plastic lids are good for mixing paints, the paint does not spread out so much. Metallic paints work well for the final spatter. Have fun.

Tracing

When tracing from an original design, I use greaseproof paper and a fine-point black pen. All details are traced. This information is useful if you intend making another card the same. I keep the tracings in a manilla folder for future use and include any notes made during painting, such as the colours used.

correct

incorrect

MATERIALS

Blue graphite paper is needed for tracing onto light backgrounds. White graphite for darker ones. There is a right and wrong side to this paper, so check beforehand with a little scatch where you are tracing.

METHOD

1. Trace printed design carefully.
2. Position design where you want it to go. Tape in place, if necessary.
3. Slide correct side of graphite paper under the tracing.
4. Lightly trace with a stylus or toothpick. Only the outlines need be traced. There is no need to trace veins on the leaves. Why? Because most of the shapes are going to be basecoated; therefore, the

fewer tracing lines the better. If there are a lot of decorative strokes (outside the main flower, for instance), just trace a line in their direction, and position. The strokes, double loaded or not, can be painted straight onto the card.

Note: Photocopy paper is thicker and harder to trace. You may need to press harder.

Hand tracing assists our drawing skills. We store these shapes in our memory. Please draw some circles or shapes with your carbon pencil where you want flowers, leaves or bows to go.

If you are tracing designs from another source, check the copyright instructions.

Embossing and Stencilling

Embossing is a pleasing embellishment to paper cards and paper art. A variety of tools and moulds is required to place designs and decorations on paper; the design is raised above the surface of the paper, making a low relief. Hand embossing is a very old craft used on papers, books, certificates and leather.

Today we use small embossing tools, laser cut stencils, machine-cut brass stencils. Embossing looks best on white and natural-coloured surfaces. Refer to M *for Margaret* card on page 47.

Stencilling is also an old craft. Stencils were used to decorate floorboards, wallpaper, canvas mats, material, walls and paper. Most embossing and stencilling designs are interchangeable, depending on the look you wish to create. A stencil taped on the window, with the right side of the paper positioned over the stencil is usually all that is needed in the way of equipment.

If you are embossing dozens of Christmas cards, a glass-topped table, with a lamp underneath would make the embossing very much simpler.

A make-shift light box is easily made by a sheet of glass or Perspex between two piles of telephone directories. Set a lamp under the glass, the light projecting upwards. Make sure the glass is secure and any sharp corners rounded off with some thick strips of masking tape.

Embossing

METHOD

1. Place stencil right side down on the glass.
2. Place paper right side down on the stencil.
3. Select which end of the tool is suitable.
4. Move the metal or wooden ball gently around the shape. A light touch here, as we do not want to pierce the paper.
5. Check results. Repeat if necessary.

Stencilling

METHOD

1. Select stencil. Hold firmly, or position with tape.
2. With small short-bristled brush, pick up a small amount of paint. Tap off excess on paper towel. Rub brush over the stencil. Press down on stencil where you are painting to prevent leakage.

Stencilling shapes can be a quick basecoating step. I often use this little short cut. It dispenses with the need to trace and saves time. The stencils need to be carefully washed in warm water and detergent after painting. Store them flat.

A wide range of stencils is available, from alphabets, baby prams, borders, flowers, bows and those suitable for home, business and school projects. I found some interesting shapes on children's rulers.

These techniques are going to give you a lot of pleasure and I hope you will enjoy shopping around for different stencils. Don't forget to decorate the envelopes, too.

Washes

Watercolour washes are done to give a soft colour change to the paper. Usually, one colour is diluted with water to start and then more paint is gradually added to obtain a darker value for light and shadow. Refer to *Flannel Flowers on sepia background* card (see page 43).

For large areas, it is good practice to first moisten the paper with a sponge. On small areas, apply water with a paint brush. Work on one area at a time. Let that part dry before moistening another area. Paint that area, allow it to dry, then start somewhere else. This method helps prevent one colour bleeding into another.

MATERIALS

A dinner plate, water, a sponge, a paint brush, and paint. A liner brush is best for fine painting.

METHOD

1. Place a small amount of paint on edge of plate.
2. Wet area to be painted on design.
3. Take a little paint and water and mix to a very thin wash. Add more water if the paint is too dark. Paint.
4. Add more paint to water to darken, and paint where the deeper colour is needed.
5. Practise on scrap paper first. Wet the area, pick up some paint on brush and apply lightly. Notice that the colour bleeds onto the wet area. Have some cotton buds handy for removing any excess paint or water.

When the designs are outlined in ink, then painted, the technique is called pen and wash.

Pen and Wash

This method of painting is wonderful for cards. It makes initials, lettering, designs and borders look more professional and realistic. A fine, permanent ink pen is an excellent drawing and writing aid. Pens are very collectable items — different points for different people. Refer to *Thoughts of Thee* card (see page 67).

MATERIALS

The requirements are the same as for washes (page 27). Use an Artline Drawing system, size 0.1 pen and black permanent ink.

METHOD

1. Trace design with blue graphite paper onto card.
2. If instructed, apply Mask 'n Peel.
3. Outline design with pen. Allow to dry.
4. Remove blue lines with a kneadable eraser.
5. Wet and wash areas with paint. Shade areas.
6. Remove Mask 'n Peel.
7. Go over pen lines, if faint. Draw fine details.

This style of painting and drawing is similar to that employed in the German Fraktur house-blessing pictures which hung on the walls of the early Pennsylvania Dutch homes. We have taken these ideas a lot further today. You are only limited by your imagination.

No matter what, no matter where,
It's always home, if love is there.

Home is where you hang your heart.

Peace to all who enter here.

Fantasy Marbling

Creating fake marble finishes on paper is easy. Coats of contrasting paints are sponged into a dry, basecoated surface in drifts of colour. A plastic bag or plastic film is then scrunched down on to the wet surface and removed, leaving fine vein lines. Further marble-like veins are applied with a feather and diluted paint of the appropriate colour.

MATERIALS

Gloves, feather, palette, plastic bag, and a mop brush for softening the feather lines. Refer to *Pink Champagne* card (see page 55).

METHOD

1. Apply a basecoat of black. Allow to dry.
2. Apply one coat of clear glazing medium. Allow to dry.
3. Apply a generous coat of Pine Green. While wet, place plastic bag down on the

paint, press and move slightly. We want creases here. Remove and discard bag. Black should be showing through in areas. Allow to dry.

4. Mix thin gold paint with water or flow medium. Pick up paint on feather tip. Tap off excess on paper towel. A very light wavy touch is needed for fine lines. Turn the feather on its side and drag it a little for more interesting vein effects. Soften any harsh lines with a mop brush.

This fantasy marble finish is just one of many interesting surface effects that you can create. The reason for creating fake finishes was that, even many years ago, marble, semi-precious stones and rare woods were very expensive. Unable to afford the real thing, people devised ways of copying them.

Today, there is a revival of interest in this finish. Classes are available not only in marbling, but in rag rolling, sponging on walls and applying gold leaf.

More information is given with the use of Kleister medium for Folk Art finishes.

I love this finish. Bold colours, soft colours, the use of metallic paints, a sprinkling of gold dust and the final touch of a little spattering produce something quite fabulous.

When you create an effect, write down the colours you used. It is often hard to remember what you did if you have to repeat the finish some time later.

Feather hunting is fun. I had no idea feathers were so interesting, and that nature made them for different purposes. I have used the tail feathers from our budgie, Harry, for fine lines on brooches and ear-rings. So, it is off to the wild for happy feather hunters. There is never a dull moment in Folk Art.

There is another method of marbling not covered in this book, which is an art in itself. It is a chemical process requiring different equipment and procedures.

Shapes and Templates

These positive and negative shapes and spaces are a wonderful 'tool' to help us make more interesting cards. The combination of techniques and shapes is endless. Once you've decided on the look you're after, it is a matter of tracing out the templates, applying surface interest and painting the design. Durable templates can be made with thick see-through plastic tracing sheets.

If you've decided the outer shape is to be sponged, and the inner shape crackled, it is best to sponge the whole card first.

METHOD

1. Trace the outline of a sheet of watercolour paper onto scrap paper using a pen. Cut out. This becomes a template.

2. Trace desired outline of centre shape, then transfer this design with graphite onto the template.

3. Cut out carefully. The inner shape is discarded. Place the outer shape, or the outer border, on the paper to be crackled.

This area of crackling becomes the negative or focal point of interest.

Borders can be traced again on the outer edge of the card. There is no end to the variety, style, and decoration that can be applied to these cards. Why not design your own shapes?

Crackling

Crackle medium is a wonderful substance that instantly ages your painting. Use it to create the most fascinating surfaces. You have the choice of using positive or negative shapes to crackle.

Crackle medium can be painted or sponged on. It can be diluted, if necessary. The consistency varies between products, and it is wise to read the label carefully before you start. Care should be taken when applying crackle medium, so that bleeding does not occur under the edge of the template. Have cotton buds on hand for quick removal of any excess.

It is wise to take time to practise when crackling on paper for the first time. Too wide a crack does not look good because the effect is too heavy. A good choice of contrasting colours is important. The nature of crackling is that you have two substances, one elastic (the medium), one not (the paint). They pull against each other as the medium dries.

One method of application involves layering the paint and the medium like meat in a sandwich. The other method is to paint the medium on top of several layers of paint. This latter method takes longer to dry.

METHOD 1

(using Duncan Quick Crackle)

Refer to *Happy Birthday Llewellyn* card (page 45).

1. Apply two coats of basecoat.

2. Apply one coat of medium with foam brush or sponge.

3. Allow to dry. Apply coat of contrasting paint. Do not drag the brush; rather, pat the paint on. Allow to dry. Paint on design.

This really is a fascinating process. Once the groundwork has been completed, the cracks appear before your eyes.

METHOD 2

(using Jo Sonja's crackle medium)
 Refer to *Pink Champagne* card (see page 55).

1. Apply four coats of paint.
2. Allow to dry. Apply a coat of medium.
3. Note that the cracks in this method are smaller. (A design can be painted before or after the medium has been applied.)
4. Dry overnight.

This is an 'instant' ageing process, unlike the cracking that occurs naturally in wood and other surfaces over the years, caused by continued fluctuations in temperature or by the chemical interaction of different qualities of paint built up on the surface over time. You can sometimes find wonderful examples (mostly expensive ones) of aged and cracked furniture in antique shops. Their charm lies in their 'weathered' appearance.

Antiquing

Antiquing is another method of ageing our work. Today, we can simulate this process in a matter of minutes.

On many old cards, some of which can still be found today, the signs of a gentle ageing process are apparent. The paper has softly yellowed, the edges are smoky and have separated. The surface in spots has faded and peeled. The surface on the writing side has mottled and the ink mellowed. The messages are meaningful.

Ageing can be achieved in several ways. Some of the methods have been covered already, such as washes, crackle and spattering.

Antiquing on paper is slightly different to antiquing on wood. On paper, we are not able to rub very hard, so our cloth must be very soft. I prefer a mop or make-up brush, cotton buds, or a slightly damp sponge. Refer to *Thoughts of Thee* card (page 67).

MATERIALS

Retarder medium, soft cloth, cotton buds, make-up brush, foam applicator brush, clear glazing medium, gloves.

PAINTS

Raw Umber and Turners Yellow. Mask edges if antiquing whole card, or cut a template and antique a shape.

1. Paint design; allow to dry. Apply two coats of clear glazing medium. The glazing acts as a protective barrier.

2. In a small jar with lid mix 10 parts Raw Umber to one part Turners Yellow and enough medium to make a thin consistency. More paint and retarder can be added, if necessary. A light consistency is needed, not a mud-like one.

3. Apply mix over whole card or shape. Don't panic. Pray!

4. This mix is now wiped off gently with a cloth, brush and cotton buds, working from the centre out to the edges. Take care to leave no fingerprints. Cotton buds can be used to uncover an area or stroke that you want to high-light.

5. Work quickly, but lightly. If you have made the finish too dark, remove with retarder. Apply more mix for a darker look.

6. Practise first. This can be a scary procedure until you've achieved some mastery of it.

The nature of the retarder medium is that it slows down the drying time of the paint. We can use this to advantage when the weather is hot and humid and when blending paint.

Some brands of paint have a range of antiquing colour mixes which can be useful. I prefer to make up my own mixes and always use water-based products and paints when antiquing.

Sometimes, there are not enough hours in the day when painting and fiddling around with these techniques. The dust quietly protects my furniture for me while I proceed with these more important duties! I have never walked into a cemetery and seen an epitaph: *'Here lies the tidiest woman in town.'*

Gold Leafing

Gold leafing is an age-old craft used to adorn cornices, carved plaster and wood. It also looks impressive on leather, frames, mirrors and furniture. Real hammered gold was used only by the wealthy.

Today, we use a composite metal leaf, obtainable in gold, silver and copper, called 'Dutch' metal. Gold leaf comes in the form of small sheets stapled between waxed or rouge paper. With careful handling, wearing cotton gloves or using tweezers (the ends of which must be padded) the leaf can be cut to size. Hands must be clean and not sweaty, otherwise the leaf will tarnish. Hold your breath while cutting. No heavy breathing, please, or the leaf will blow away. The leaf and rouge or wax paper are used together.

On our cards, positive and negative shapes can be gold leafed, as well as initials, leaves, flowers and so on. Refer to *Thoughts of Thee* (see page 67).

Gold leafing can be quickly mastered. It is one of my favourite finishes; I do get carried away with it. The results are never quite the same each time. While painting and gilding and making cards, we tend to forget some of our daily stresses and problems.

MATERIALS

Cotton gloves, tweezers, tannin blocking sealer, gold leaf, scissors, applicator brush, cotton balls, cake of soap and water, varnish and Indian red oxide paint.

METHOD

The sealer is the glue. The Indian red oxide paint is applied to the area to be leafed. Should any tears occur, the red under the gold looks more attractive than stark white paper. Other colours can be used such as black and dark blue. The ends of the tweezers are padded with cotton wool tied on securely with sewing thread.

1. Mask off the area to be gold leafed, if necessary.

2. Apply one coat of Indian red oxide where the leaf is to go.

3. When dry, apply two coats of tannin blocking sealer. The second coat can be applied when the first is still slightly tacky. The paint and sealer need to be applied carefully because any ridges will show through on the leaf. Refer to *All That Glitters* (see

page 51). On this card, the centre was gold leafed and painting was done around the edges.

4. With gloves on, place leaf down on the adhesive with the wax paper on top. Gently roll your index finger or thumb over the paper, making sure every part has adhered before you remove gloves and the wax paper.

5. Allow several hours to dry; overnight if possible.

6. Dip a cotton ball into warm water and rub it over the soap, it should not be too wet. Rub cotton ball gently over gold leaf. The excess gold leaf will come off the edges. Take care; you do not want to tear the leaf. Small cracks with the red showing through are very pleasing, but not wide ones. Repeat the process, if necessary, on any areas you are not happy with.

7. If you are planning an intricate painting design, it is advisable to apply a coat of protective varnish over the leaf before painting. The paint adheres better and the leaf does not tarnish.

8. Techniques such as antiquing, washes and spattering all look stunning on gold leaf.

GLITTERING IDEAS

Glitter can be applied to the tannin blocking sealer. Use a little more pressure. I like to mix the glitter with some varnish for extra adhesion. Glitter dimensional pens have already been mentioned. Refer to *Lettering* (page 6).

Gold dust is sprinkled onto the adhesive and pressed down firmly with scrap rouge paper. The excess is tapped off, not blown. Dry. Repeat application, if necessary, by mixing a little dust with varnish. When dry, apply a coat of varnish. Refer to *Golden Strawberries* card (page 48).

Kleistering

Kleister medium is a modern, semi-transparent medium. When mixed with paint, we can obtain the most intriguing finishes on which to work, or we can simply enjoy them as works of art in their own right. Kleister medium dries flat, like a basecoat, yet the effect is three-dimensional. You will love this technique.

In the past, the same effects were created with a paste made of starch and water or flour and vinegar. The borers loved this mixture on wood and the insects loved it on paper, so much was lost and eaten. However, some examples have survived. Wood and leather grain were imitated with special rollers with grooves, and can still be found in fine collections today. I have a large metal hat box. The finish resembles crocodile skin and the paint appears to have been applied with a roller. I haven't made up my mind yet how I am going to paint it.

Kleister effects on paper look wonderful, I am sure that once you have mastered this technique, the possibilities for you are endless. Many textural effects can be obtained with experimentation, time, patience and inspiration.

Kleistermalerei was the Austrian and German name for Kleister painting, whereby lovely fake wood grains were created. We have taken this a lot further today, and are obtaining some lovely finishes.

MATERIALS

Kleister medium, clear glazing medium, applicator brush, cardboard toilet rolls, plastic bags, combs, paper doilies, scrunched up foil — in fact, anything that will give a patterned effect. Refer to *Shimmering Doilies* card (page 77). Paints: Pearl White, Ultramarine Blue.

METHOD

1. Basecoat the card with Pearl White. Allow to dry.

2. Apply one coat of clear glazing medium. Allow to dry.

3. Mix equal parts of Kleister medium and Ultramarine Blue. Drag the brush when applying thickly to give the appearance of lines. Working quickly, place the rounded section of a paper doily over a wet area. Press and remove. Cut out another piece of border from the doily, press and remove. The Pearl White should be showing through. Position more border segments if required. I search for different patterns; a rose border was used in this example. Try the wrong side of the paper, and see what happens. Mask off or cut out templates for different shapes.

4. Dry and paint design.

Several ideas have been developed on the cards, the details of which are given in the instructions.

I am quite certain that some of you very clever people will come up with some amazing surface effects for yourselves. Happy Kleistermalering.

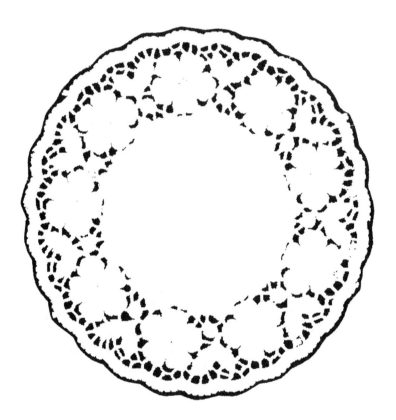

SAYINGS

I have included some sayings and 'pearls of wisdom' which may be appropriate to the recipient of the card and the occasion for which it was created. All the authors are anonymous.

It may be hard for you to write on your beautifully painted card, but how lovely it will be for the recipient. A personal note or a message with one of these sayings incorporated would be a very expressive form of communication.

Our favourite flowers have meanings. The pansy symbolises thoughts, and many poems have been written about it. I see pansies as clowns; warmhearted and colourful friends in the garden. Complement your chosen image with an appropriate message.

There are so many reasons to write to people. Some are sad occasions, some happy. We all like to receive letters and cards in the mail. What an interesting way to send an account! I love this message from Sid to Bessie on an old card I have. 'Dear Bessie, I wish you a merry birthday and I hope you never die, till a dead horse kicks you. From Sid.' I wonder if they had a future together.

A lot of interesting sayings and verses abound in autograph books, and there are volumes of quotes in the library. Why not start a collection for your own use?

No one walks backwards into the future.

May He whose birthplace was a manger,
bless and protect the little stranger.

Flowers are the friends
in the garden of Life.

Nothing is more precious than a day well lived.

Mother.
A kindly word, a kindly deed.
A helpful hand in time of need.
Feeling for others, bearing the pain.
Freeing the fetters, undoing the chain.

What sunshine is to flowers,
smiles are to humanity.

Earth has no sorrow, that Heaven cannot heal.

I sincerely hope there will be painting and writing in Heaven.

MAKING ENVELOPES

*T*he smaller flap envelope is made from foolscap paper and the larger flap one from larger sheets. Save all scrap paper. The larger pieces can be used to make template shapes. The glue can be a roller type or paste in a bottle.

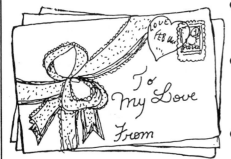

Suitable papers are:

- Brown paper, purchased in sheets or rolls.
- Calligraphy paper, Skytone Text. A3 x 10 sheets. This will give you 20 envelopes for a cost of approximately $3.00.
- Canson paper comes in various colours. It is a thicker paper, and more expensive, but if you are wanting a particular colour to match your card the colour range is very wide.
- White cartridge paper priced from 20 cents to 40 cents per sheet, will make three larger flap envelopes.
- Recycled paper from supermarkets in foolscap pads or scrapbook paper is good and very economical. 30 sheets for $1.00.

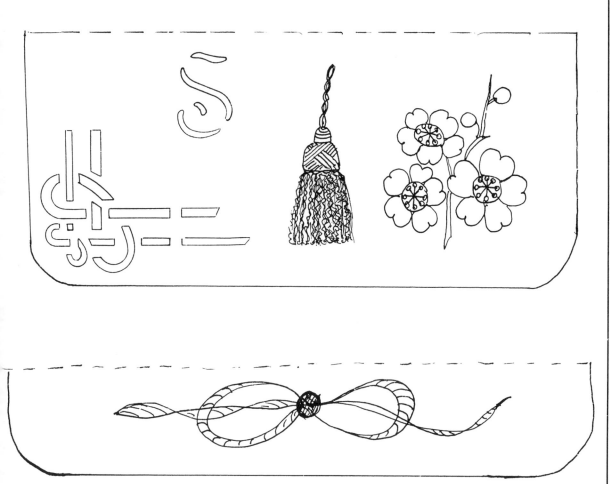

METHOD

1. Trace the pattern for the small or large flap envelope (see page 41) onto tracing paper and transfer this pattern with Saral paper onto cardboard. Cut out the cardboard pattern carefully. You now have a strong template that you can use repeatedly. Do not fold it.

2. Place the cardboard template on envelope paper and trace around it with a pencil. Cut envelope out carefully. Crease along folds with the handle of a pair of scissors. Glue along two side folds. Trim, if necessary.

I often make several envelopes at a time so I have some spare stock. Try to be different. Apply washes inside the flap, or try sponging.

Paint bows or a tassel, emboss, stencil and paint little designs that match. Your envelopes could become collectible treasures, too.

fold in

fold

Templates for Envelopes

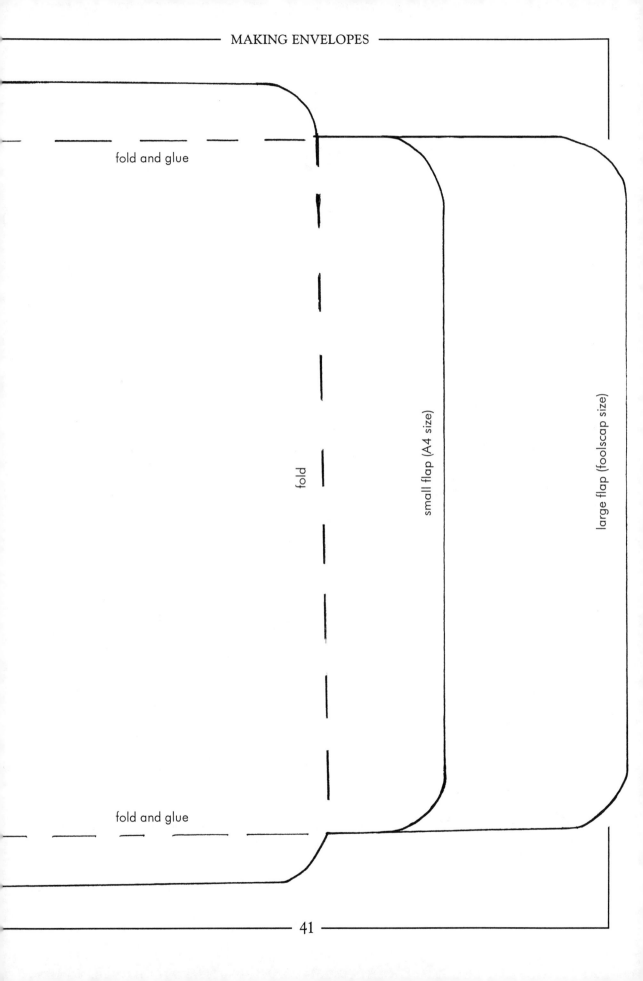

fold and glue

fold

small flap (A4 size)

large flap (foolscap size)

fold and glue

PROJECTS

dotty ways

stylus hearts

stylus strokes

end of paint brush

border

Simply Sponged — for beginners (Plate 1)

TECHNIQUES

Sponging. Embossing. Stencilling. Tracing. Spattering.

BASECOAT

Pearl White. (For your next card try Gold or Pink.)

COLOURS

Pearl White. Rich gold. FolkArt-Rose Shimmer.

METHOD

Sponge over basecoat diagonally in drifts of the colours like a rainbow. You will obtain some lovely colour values here. Stop sponging when you are satisfied with the effect and allow to dry. Sponge a gift card, another card or the envelope with leftover paint.

MESSAGE

'Congratulations'. Trace the word using blue or white Saral paper. Paint lettering with two or three coats of Pearl White, adding a little pink at the base of the letters. Paint some dot flowers or spatter some white or pink paint on the card.

EMBOSS

Emboss or stencil with a pre-cut Plaid stencil. I used some hearts and a corner stencil. Note that embossing does not always show up effectively on coloured surfaces. Also refer to 'M' *for Margaret*, page 47.

ENVELOPE

Made from white paper, sponged or stencilled on the flap. Spatter on front, just to be different.

Busy hands — Happy hearts. Anon.

Flannel Flowers on sepia background
(Plate 1)

Here, you will learn to use masking fluid (Mask 'n Peel). I am sure you will find many uses for this such as on borders, for small dots, shapes and various flowers.

TECHNIQUES

Masking. Washes. Spattering. Liner work.

COLOURS

Teal Green. Warm and Titanium White. Brown Earth.

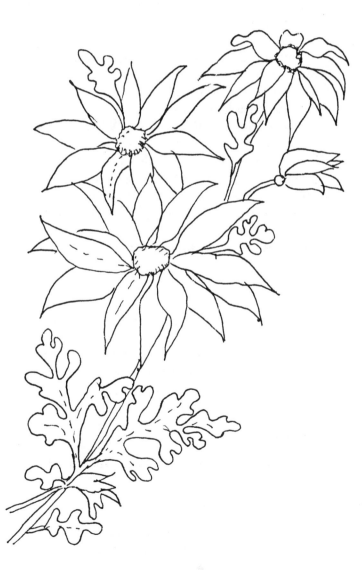

METHOD

Trace design onto card using blue Saral paper. With fine brush, paint Mask 'n Peel on flowers and leaves.

When dry, wash card all over with a very pale wash of Brown Earth, add more paint and darken area around flowers and leaves. Spatter with Brown Earth. When dry, remove the now rubbery Mask 'n Peel. Rub out lines with kneadable eraser.

Make a mix of Teal Green and Warm White to make a grey-green colour. Paint leaves. Put blobs of Titanium White on centres. Add a little of the green mix on one side and Teal Green on the other side and mix lightly. With liner brush, pull out some fine green lines from the centre, the tips of the petals and veins on leaves with Teal Green. Add more paint to centres when dry; the centres are quite full and fluffy.

MESSAGE

A personal note written with a brown pen. A good card to send overseas.

The botanical name for the flannel flower is *Actinotus Helianthi*. A professional touch would be to write this with a fine tip pen along the stem.

ENVELOPE

The calligraphy paper is a good match. Apply some spatter or paint a small bow.

A world without flowers,
is like a sky without stars.

Happy Birthday Llewellyn (Plate 1)

TECHNIQUES

Crackling. Pen outline. Spattering.

BASECOAT

Carbon Black.

COLOURS

Carbon Black. Ultramarine Blue. Warm White. Pearl White. Peach (mix Norwegian Orange and Warm White).

METHOD

Over basecoat, apply Duncan Quick Crackle, following instructions on bottle. Paint Ultramarine Blue on top. When dry, trace design and apply onto surface using white Saral paper. Basecoat whole design with Warm White; two coats may be needed. Paint over again with Pearl White. Make the Peach mix and paint fine lines with liner brush on centres and buds. Outline whole design with Artline drawing system pen, drawing in centres as illustrated. The petals are a heart shape.

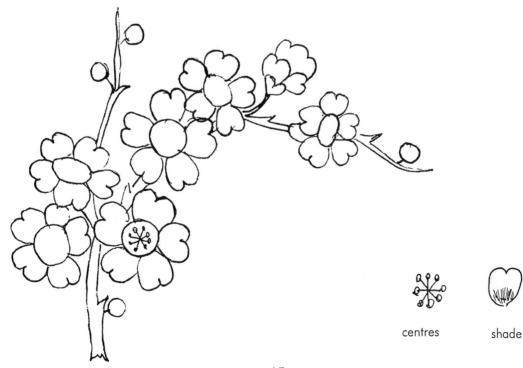

centres shade

Happy Birthday

ENVELOPE

Make from white, black or blue paper. Spatter a mixture of leftover paint on flap.

MESSAGE

'Happy Birthday' written with white pen, or painted with Peach mix and Pearl White using the liner brush.

In Japan, in the Nara and early Heian periods, papers were decorated and painted with designs and techniques using mother of pearl, mica, gold and silver dust. Onto this surface, poems of 31 syllables were painted. These Waka poems were a means of communicating love and joy of nature and beauty. This combined the skills of the poetry lover and the artist.

I have only tried the 17-syllable Haikus, pruning words to fit into three lines, of five, seven, then five syllables. We stay in the country sometimes, and this inspired me to write some Haikus.

Wind whispers in trees,
twigs strain, leaves clap quietly,
pine needles singing

Another:

Reeds rustle a song,
moon caresses sleeping geese,
pearls, on velvet pond

'M' for Margaret (Plate 2)

TECHNIQUES

Embossing. Stencilling. Washes. LAFS. Blending.

STENCILS

Plaid embossing and monograms.

COLOURS

Rich Gold. Napthol Crimson. Warm White.

BORDER

Folk Art Aquamarine Metallic.

METHOD

Gently emboss the initial and the stencil you prefer, using your special embossing tool.

Apply washes with Aquamarine around the border, darkening towards edges. Do not paint over embossed areas.

Wash a pale pink mix of Warm White and a dash of Napthol Crimson around centre initial, and beside the other embossing.

Refer to LAFS and Flat Brush Blending, and paint trails, leaves, roses and buds. The dagger brush leaves utilise a thin wash of a mixture of Rich Gold and Aquamarine.

FINAL TOUCH

Place some gold dots and liner brush work on leaves and stems. Paint and scatter small pink and white filler flowers.

Place the two colours on the brush and just push the paint, one, two, three, four, five times in a circle. Place a dot of white or gold in the centre; these little charmers fill up a lot of spaces on the cards.

MESSAGE

A personal one. With any leftover paint, make a small gift card, or sponge another card. These colours will blend and sponge beautifully.

ENVELOPE

Large white flap, painted in the LAFS. Why not emboss another 'M' for practice and for Margaret? Write with a green or pink pen.

For you upon your Birthday,
May joy's fair star shine clear,
And Happiness and Peace abide,
Through every coming year

Found on an old card, Anon.

Golden Strawberries (Plate 2)

BASECOAT

Black. Trace design with white graphite.

TECHNIQUES

There are four methods here for you to choose from.

Method 1: Basecoat leaves and berries with two coats Pale Gold; allow to dry. Paint black liner work on leaves, dots on berries, or use fine black pen to draw lines.

Method 2: Basecoat leaves Pale Gold, two coats. Basecoat the strawberries Rich Gold, two coats. Apply black liner work or black pen. Painting Rich Gold and then Pale Gold makes a brilliant effect.

Method 3: Gold leaf is applied to either to the leaves or berries, then liner work.

Method 4: The card was painted with gold dust. Basecoat leaves and berries Rich Gold. Then apply tannin blocking sealer, then gold dust. When dry, varnish and do liner work.

FINAL TOUCH

With Rich Gold, add some decorative border strokes. Paint back of card Black.

MESSAGE

Personal. Written with a gold pen.

ENVELOPE

Black. Gold spattering or Gold liner work.

Now that you are a card painter, I hope you will become a card writer, writing in your own way about feelings in your heart.

Another golden oldie found on a card; 'To Robyn from Judy'

Tis not a costly Token,
And the Words are simple and few,
But they bear a loving Greeting,
A Glad Birthday for you.

Anon.

Strawberries and Cream (Plate 3)

TECHNIQUES

Round brush blending. Shading. Highlighting.

BASECOAT

Folk Art Tapioca.

COLOURS

Magenta. Warm White. Jade. Burgundy. Pale Gold.
Pink Mix = Magenta plus Warm White.

METHOD

Trace design using blue graphite. Basecoat the leaves
with Jade, the strawberries with Magenta. Blend pink
mix on left, Burgundy on right, blend Magenta all over
and highlight with Warm White. Leaves are blended
the same way as shown in illustration.

Paint border with a wash of Magenta followed by
Rich Gold. Then apply dots of Burgundy and Pale Gold
around edge and on strawberries. Small double-loaded
strokes. Warm White and Jade on strawberries.

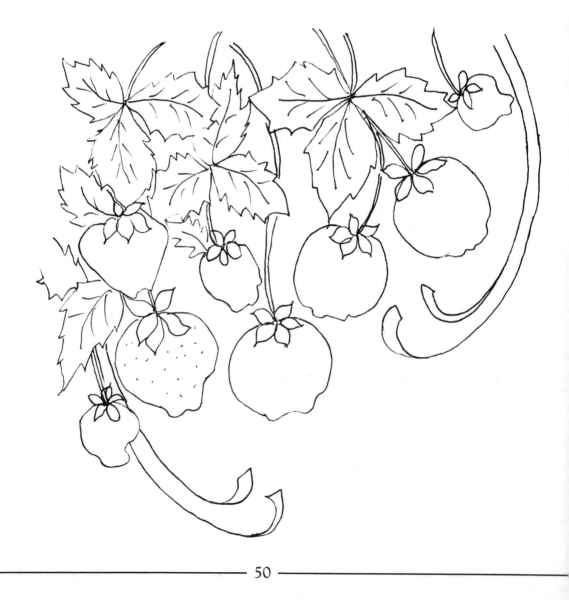

LINER WORK

Fine Magenta veins on leaves. Fine Magenta tips on one side of leaves, and Warm White tips along the other side.

MESSAGE

A personal one. Perhaps you know of someone who needs cheering up, or of someone who has lost kilos and more kilos, and can now indulge again.

ENVELOPE

Pink or cream, with seed dots and spattering.

To Aphra from Anthea

> *May Fortune Fair and Joy agree,*
> *To make this Birthday Bright for Thee.*

Anon

In presenting two cards painted from the same design, you can see that all the cards presented in this book can be changed and painted in different ways. Why not paint mauve strawberries, or blue. Have fun while you are painting.

All That Glitters (Plate 2)

TECHNIQUES

Kleister. Gold Leaf. Light Airy Fairy Style.

BASECOAT

Rich Gold two coats. Apply two coats of Clear Glazing Medium.

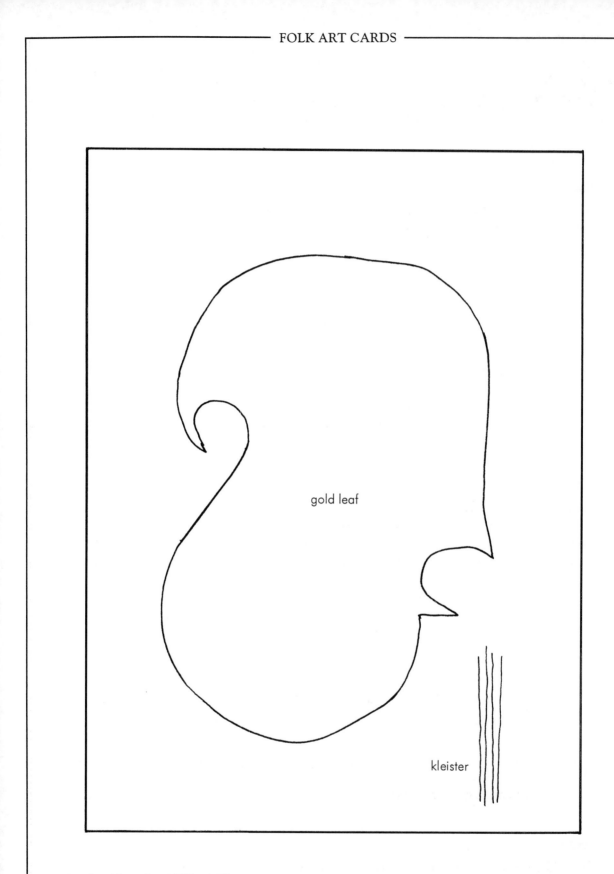

gold leaf

kleister

Template for All That Glitters

COLOURS

Rich Gold. Silver. Ultramarine Blue. Napthol Crimson. Warm White. Turners Yellow. Storm Blue. Pine Green. Indian Red Oxide.

METHOD

Dry basecoat and Medium well. Mix one part Silver and one part Kleister Medium. Paint over whole card. Drag mix down length of card with nylon nail brush. Keep straight, and there is a lovely old fashioned effect of gold and silver lines. Next time wobble the brush and you will have some waves. Cut and trace template. Apply two coats of Indian Red Oxide over centre shape. When dry add Gold Leaf. Refer Colour Guide and paint daisies. Note that they are darker on one side. Light Airy Fairy Strokes of small trails and stems and filler flowers complete the card.

MESSAGE

'Thinking of you.' 'Your Friendship means a lot to me.' 'Keeping in Touch.' A card for remembering friends, kindnesses, old times with affection and nostalgia.

ENVELOPE

Blue or red paper. Kleister the flap or front with remaining mix. Paint some daisies. This is a card and envelope to be treasured.

> *Whoever has a friend with whom to share,*
> *Has double the joy and half the care.*

Anon

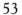

Rose on Moss Covered Wall (Plate 3)

TECHNIQUES

Kleister. Glitter paint. Round and flat brush blending.

BASECOAT

Teal Green. Duncan Sand 238.

COLOURS

Teal Green. Green Oxide. Rich Gold. Napthol Crimson. Warm White.

METHOD

Apply one coat Clear Glazing Medium to Teal Green Basecoat. Mix one part Kleister Medium to one part Warm White, apply to card fairly thickly. Roll cardboard toilet roll over mix until a mossy look is achieved. Use a new cardboard toilet roll each time if the process has to be repeated. Trace template shape. Apply two coats of Duncan Sand to outer border. Paint and blend leaves, buds and rose as per colour guide.

FINAL TOUCH

for template see
Chinese Cloisonné
(page 72)

Squeeze glitter pen dots around border. Dagger some red and gold thin wash leaves close to other leaves.

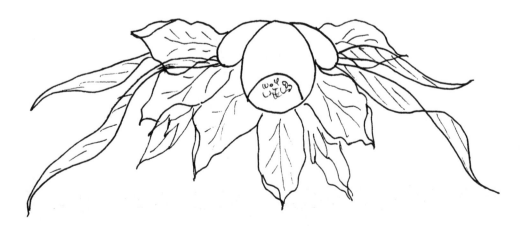

MESSAGE

Trace or write freehand, 'Mother' with the Glitter Dimensional paint. Dry well.

ENVELOPE

Green or red paper. Add some 'mossy' kleister mix on flap or front of envelope. Paint a bow or gold dots. This is a special card.

There is a place in the human heart, only a Mother can fill.

Anon

Pink Champagne (Plate 3)

TECHNIQUES

Masking off. Crackling. LAFS. Round brush blending. Fantasy marbling. Spattering, if desired.

BASECOAT

Black for marbling and four coats of Tapioca for strip.

COLOURS

Plum Pink. Burgundy. Warm White. Black. Rich Gold. Marble-green mix is Green Oxide and Pthalo Green with a little Kleister medium added.

METHOD

Marble the card. Feather with Rich Gold. Spatter with Rich Gold or Tapioca. Dry. Apply two strips of masking or Magic Tape across the card leaving a space of 2.5 cm (1"). In this space apply four coats of Tapioca. When dry, apply one coat of Jo Sonja's Crackle medium. Remove masking tape and allow to dry overnight. Refer to LAFS and apply some trails and dagger leaves in groups of three with Green Oxide and liner work of Pthalo Green. The grapes are painted one at a time,

using the round brush blending technique. Paint another grape on top. Mix the colours; basecoat in Burgundy for instance, and darken with Pthalo Green for shade mix. Lighter grapes are a mix of Plum Pink and Warm White, shaded with Plum Pink and highlighted in Warm White.

MESSAGE

I guess 'Congratulations' are in order here, written on the back.

ENVELOPE

Bottle green, of course. Spatter pinks, green gold and tapioca.

Congratulations to you, too. You have painted the entire card with no tracing, all freehand. Well done!

A hug and a hand painted card is worth a thousand words

Congratulations

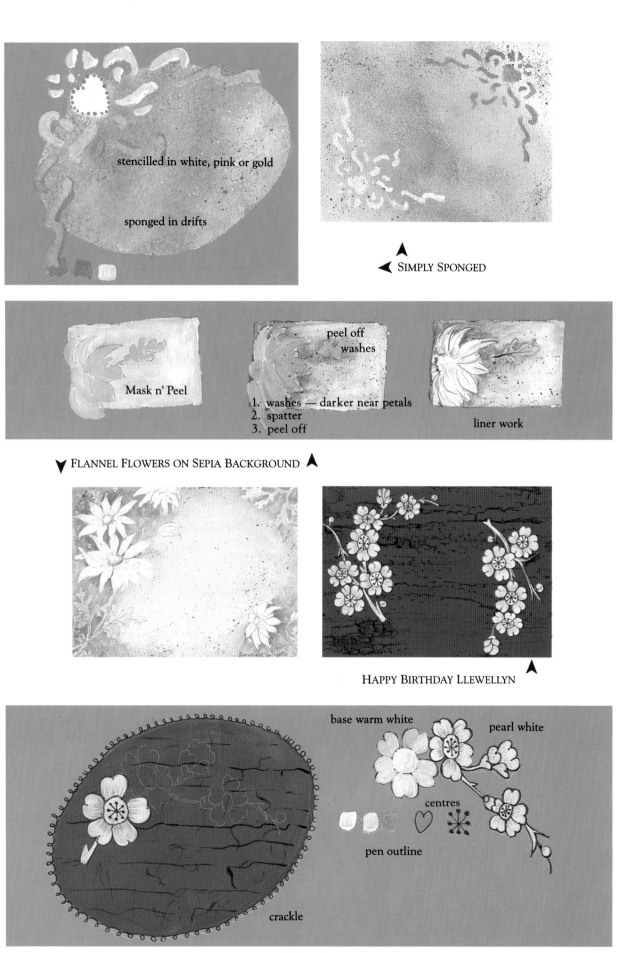

stencilled in white, pink or gold

sponged in drifts

▲
◄ SIMPLY SPONGED

peel off washes

Mask n' Peel

1. washes — darker near petals
2. spatter
3. peel off

liner work

▼ FLANNEL FLOWERS ON SEPIA BACKGROUND ▲

HAPPY BIRTHDAY LLEWELLYN ▲

base warm white

pearl white

centres

pen outline

crackle

Plate 1

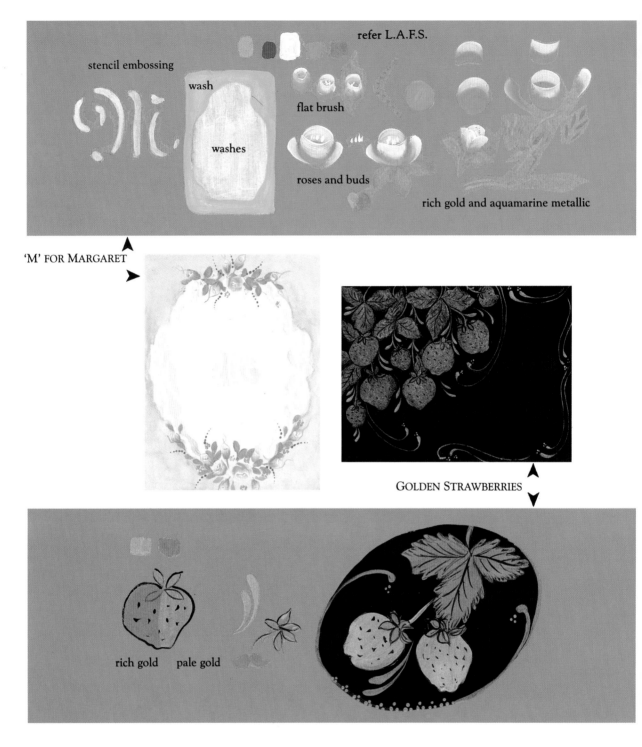

refer L.A.F.S.

stencil embossing

wash

washes

flat brush

roses and buds

rich gold and aquamarine metallic

'M' FOR MARGARET

GOLDEN STRAWBERRIES

rich gold pale gold

ALL THAT GLITTERS

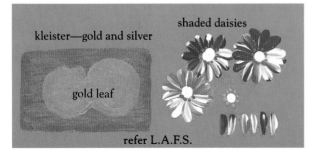

kleister—gold and silver

shaded daisies

gold leaf

refer L.A.F.S.

Plate 2

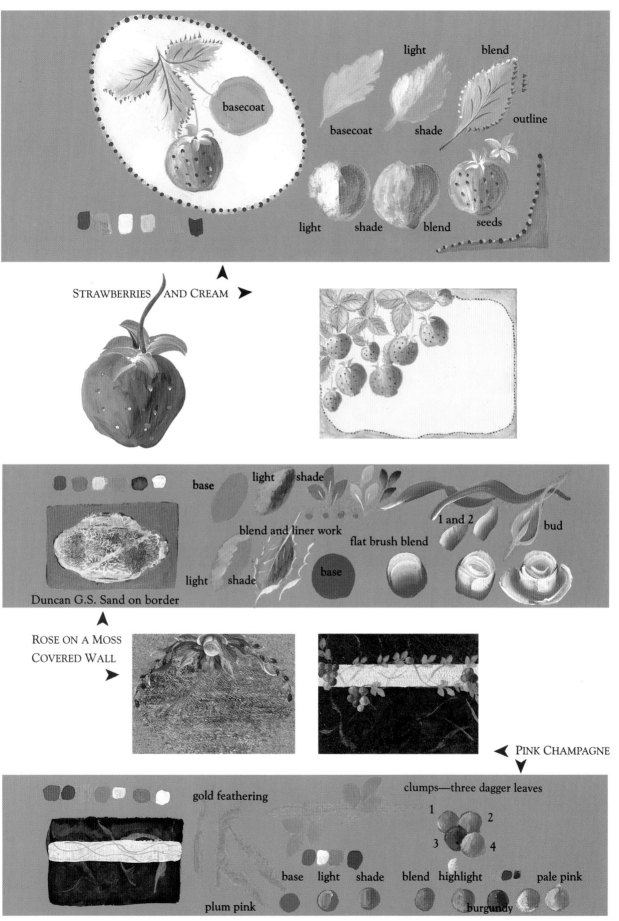

STRAWBERRIES AND CREAM

basecoat

light

blend

basecoat

shade

outline

light

shade

blend

seeds

ROSE ON A MOSS COVERED WALL

base

light

shade

blend and liner work

light

shade

flat brush blend

base

1 and 2

bud

Duncan G.S. Sand on border

PINK CHAMPAGNE

gold feathering

clumps—three dagger leaves

1

2

3

4

base

light

shade

blend

highlight

pale pink

plum pink

burgundy

Plate 3

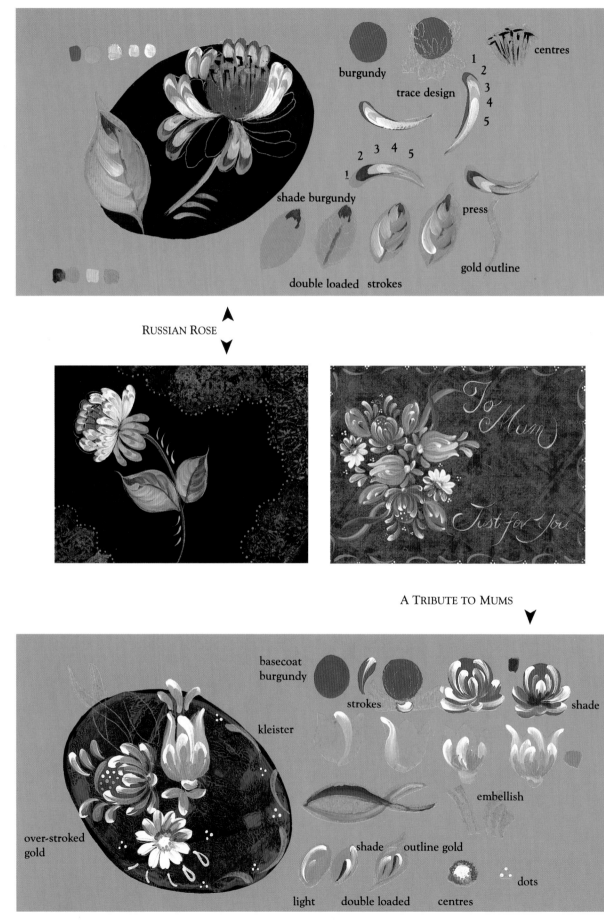

centres

burgundy

trace design

1
2
3
4
5

shade burgundy

2 3 4 5
1

press

gold outline

double loaded strokes

RUSSIAN ROSE

A TRIBUTE TO MUMS

basecoat
burgundy

strokes

shade

kleister

embellish

over-stroked
gold

shade outline gold

dots

light double loaded centres

Plate 4

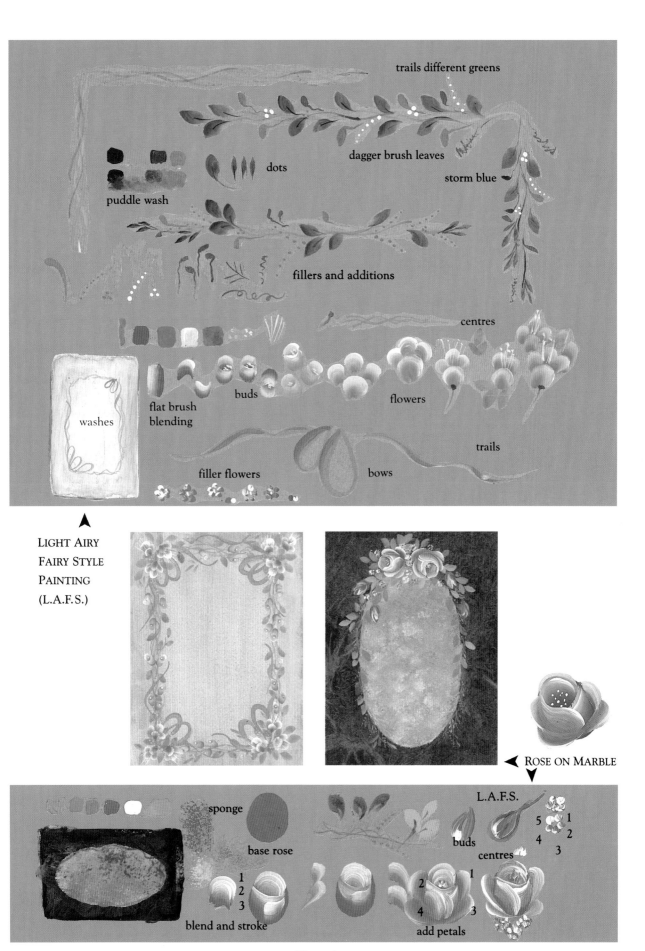

trails different greens

dagger brush leaves

storm blue

dots

puddle wash

fillers and additions

centres

washes

flat brush blending

buds

flowers

trails

filler flowers

bows

LIGHT AIRY
FAIRY STYLE
PAINTING
(L.A.F.S.)

ROSE ON MARBLE

L.A.F.S.

sponge

base rose

buds

centres

5 1
4 2
3

blend and stroke

1
2
3

2 1

4 3

add petals

Plate 5

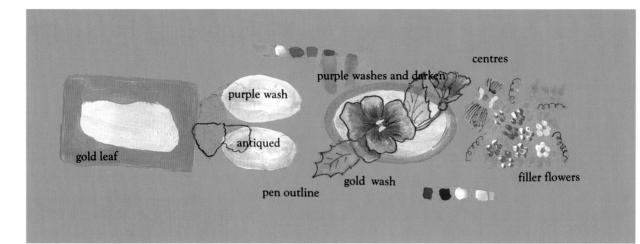

gold leaf

purple wash

antiqued

pen outline

purple washes and darken

centres

gold wash

filler flowers

THOUGHTS OF THEE ▼

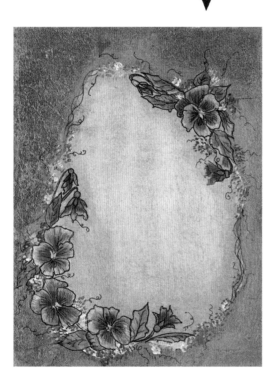

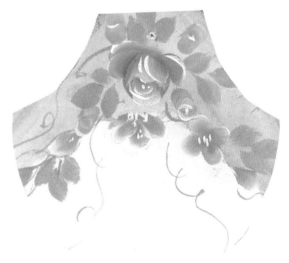

▲

COVER, GIFT CARDS, ADDRESS BOOK, ENVELOPES

▼

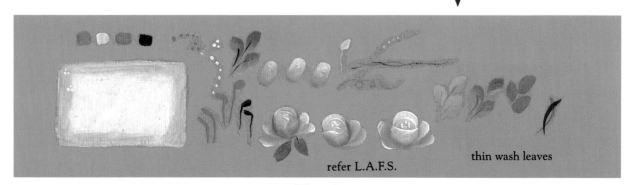

refer L.A.F.S.

thin wash leaves

Plate 6

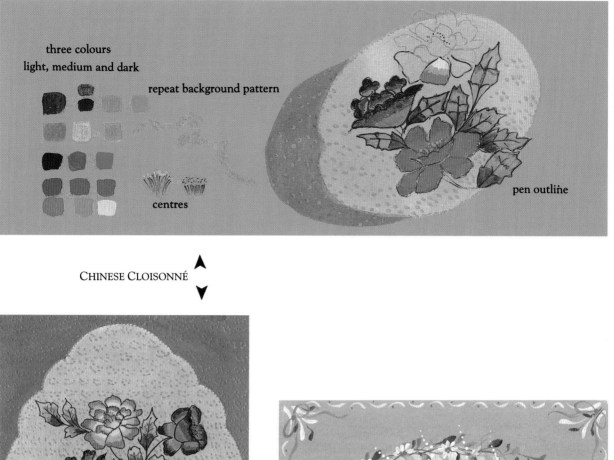

three colours
light, medium and dark

repeat background pattern

centres

pen outline

CHINESE CLOISONNÉ

Happy Birthday

HAPPY BIRTHDAY DAISY

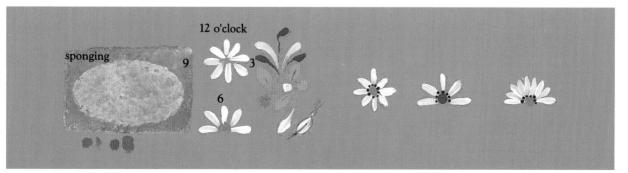

12 o'clock

sponging

9

3

6

Plate 7

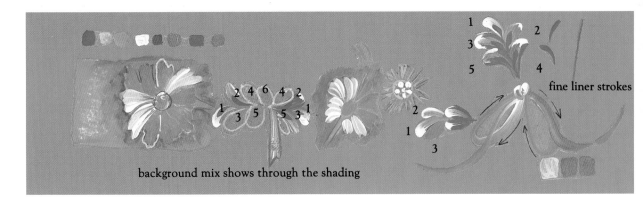

background mix shows through the shading

fine liner strokes

SIMPLY STROKED

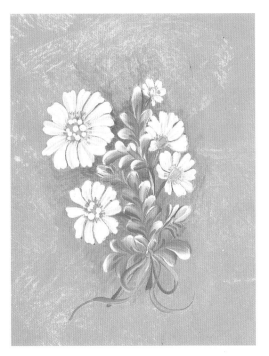

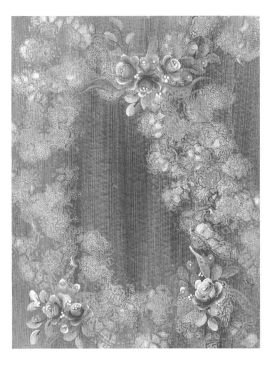

SHIMMERING DOILIES

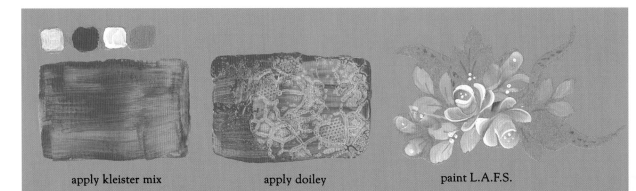

apply kleister mix

apply doiley

paint L.A.F.S.

crackled strip

Template for Pink Champagne

Russian Rose (Plate 4)

TECHNIQUES

Stroke painting (double loaded brush Kleistering), alternating colour effect.

BASECOAT

Black. Base for rose, Burgundy; for leaves Green Oxide.

COLOURS

Burgundy. Green Oxide. Pine Green. Rich Gold. Warm White. Pink mix: Warm White and Burgundy two values.

METHOD

Trace design using white Saral. Only paint the ball of the rose and basecoat the leaves. Follow numbers on the petals and leaves. The values of pinks on the rose alternate to give the effect of light and shadow. These are double loaded with Warm White or Pink Mix. The small leaves under the rose are painted in the same way. For large leaves, refer to the colour guide. The strokes for these are double loaded.

FINAL TOUCH

Some small pink strokes with liner brush on stems, and around top of flower. Liner work with Rich Gold on leaves. Mix Rich Gold with Kleister medium and paint onto a paper doily. Press onto black. Complete with gold dots around border edge. Paint back of card with Black.

MESSAGE

Invitation to an intimate dinner party with a Russian theme, food and dancing.

ENVELOPE

Black with large flap. Press more paper doily shapes here.

I have several Russian painted metal trays, and think this style of painting is exquisite. Many of the original tray painters were anonymous peasants, yet artisans of remarkable skill and talent. How I would like to paint as they did.

Tortoiseshell was a popular faux finish. Gold and silver, mother of pearl and metal dust were also used. Together with the painting techniques, this style of decoration required several heat processes to achieve the finish we see today. Trays are still being painted in this manner today in the small village of Zhostovo, outside Moscow. As well as metal, painting on papier mâché is also a traditional craft.

The stylised version of a rose depicted in this card project is just a simple interpretation that I find so charming on my trays.

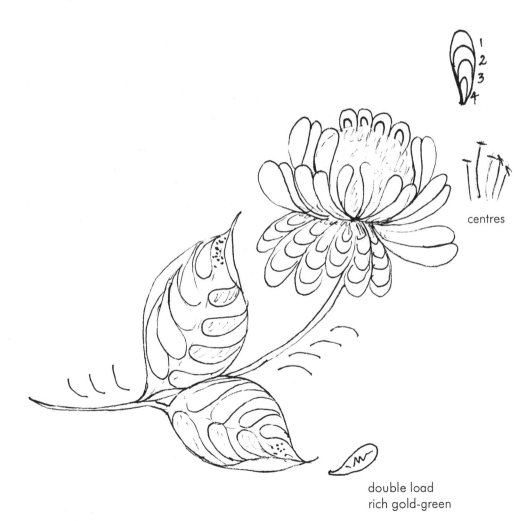

centres

double load
rich gold-green

Russian Rose

A Tribute to Mums (Plate 4)

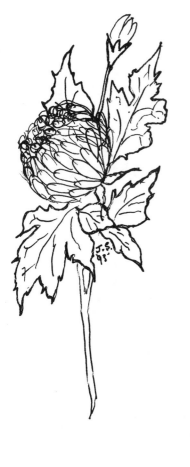

TECHNIQUES

Kleistering. Bavarian stroke painting.

BASECOAT

Black. Mix Kleister Medium and Ultramarine Blue.

COLOURS

Black. Ultramarine Blue. Burgundy. Warm White. Gold Oxide. Turners Yellow. Green Oxide. Pthalo Green. Rich Gold.

METHOD

Apply basecoat, allow to dry. Apply two coats of clear glazing Medium. Dry. Mix equal parts of Kleister Medium and Ultramarine Blue and apply. Using cardboard toilet roll, roll in one direction, wipe on paper towel and roll in opposite direction. This will produce some texture and fine lines. When dry, trace on design using white graphite paper and basecoat the flowers and leaves as illustrated. The daisies are painted in the same way as for *All That Glitters* (see page 51). The embellishment and decoration is done with double-loaded strokes, then overstroked with fine Rich Gold strokes.

The ribbon trails are a dark blue mix for one and a lighter blue and white mix for the other.

To Mum

Just for You

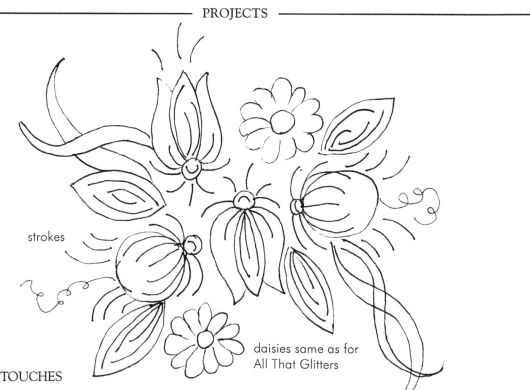

strokes

daisies same as for
All That Glitters

FINAL TOUCHES

With liner brush and Rich Gold, decorate border and
leaves and overstroke on the flowers and leaves. Small
dots are added here and there and around the border
and look very good. Outline the ribbon trails.

MESSAGE

To Mum, Just for you.

ENVELOPE

A blue envelope with a large flap on which is applied
more Kleister mix. This time, apply the mix direct to
the roller, and roll it onto the envelope. Writing with
a white pen would add an original touch.

An old verse, on an old card.

> *In old Japan the*
> *flower above*
> *Twixt maid and man*
> *conveys 'I Love'*
> *When passed between the two:*
> *We cannot meet, and so dear friend*
> *In tender greeting I now send*
> *Chrysanthemums to you*

Light Airy Fairy Style of Painting
(Plate 5)
My own Style

TECHNIQUES

Washes. Flat brush blending. Dagger brush. Liner work.

BASECOAT

Tapioca.

COLOURS

Plum Pink. Rich Gold. Pine Green. Sapphire. Warm White.

METHOD

Thin washes of Plum Pink, then Sapphire, are applied over the basecoat. More Sapphire is applied to the border, becoming darker towards the edges of the card.

With liner brush, paint trails with Pine Green. Paint leaves with a washy mix of Rich Gold and Pine Green using a dagger brush. Using a liner brush, paint loops and trails of ribbons in a thin wash of Plum Pink and Rich Gold. With flat brush and using the blending technique, paint in groups of buds of Plum Pink and Sapphire. Paint Sapphire flowers as illustrated. Apply groups of three gold dots here and there. Paint dots of Warm White in buds with stylus or toothpick and liner work the stamens in flowers.

MESSAGE

This card is suitable for a number of occasions. I chose an anniversary message.

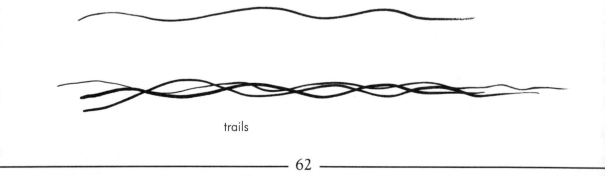

trails

dagger brush

all set up ready for flowers

ENVELOPE

Natural paper with the same style of painting on the flap and envelope.

> *Faded mauve roses*
> *symbolise our long union*
> *through life's many shades*

A Haiku from my friend Georgette Wall.

My intention with the 'light airy fairy style' of painting is to get you painting freely right from the start. If you follow the step-by-step guide on the colour plate, you will be able to start painting in this manner once you have applied a basecoat, and selected a template or technique such as sponging, crackling or marbling.

Using a liner brush, stems and trails are painted over and under each other in different shades of green.

The dagger brush leaves come next. Several colours are placed close together, pulled down and mixed thinly with water and often gold. Ribbons and loops can also be painted in now. What you are doing is a little like floral art in that you are setting up a suitable background for the flowers. Daisies, pansies, berries, roses and buds in different colours are used. Filler flowers described in 'M' for Margaret are used to fill up gaps. Be as creative as you like here.

I use this technique for painting large items such as trunks, old suitcases, screens and so on, but, of course, larger brushes are needed. Sometimes I might just paint trails, leaves and small dots for berries. These are painted on the small gift cards in the colour plate on the cover.

This LAFS is a no-fail way of painting freely. There is nothing to trace. You are painting!

Roses on Marble (Plate 5)

TECHNIQUES

Kleistering. LAFS. Flat brush blending. Sponging.

BASECOAT

Black. Apply two coats of Clear Glazing Medium.

COLOURS

Pine Green. Norwegian Orange. Warm White. Rich Gold. Black.

METHOD

Mix Kleister medium and Pine Green. Apply. Place a plastic bag on the surface and move it gently around; remove. This is the basis for a marble finish. Cut out oval-shaped template as shown on page 66. Sponge Warm White and Norwegian Orange onto inset until you have a pleasing result. Refer to LAFS, and paint the trails and leaves Pine Green. Mix a little Pine Green

and Warm White for paler leaves. Basecoat shape for roses and, with flat brush, paint petals on roses and buds. Filler flowers of Norwegian Orange and Warm White are applied at the base of the roses.

FINAL TOUCH

Graduated gold dots made with a stylus or satay stick.

MESSAGE

This card is suitable for several occasions such as sickness, thanks, thoughts and birthdays. The message is written with a green pen.

ENVELOPE

Natural colour, small flap with some spattering. The address is written with green pen.

I found this verse on an old card written from Ellie to Phyllis.

A Bright and Happy Birthday,
So goes my wish to you —
Just a simple greeting,
Heartfelt though and true

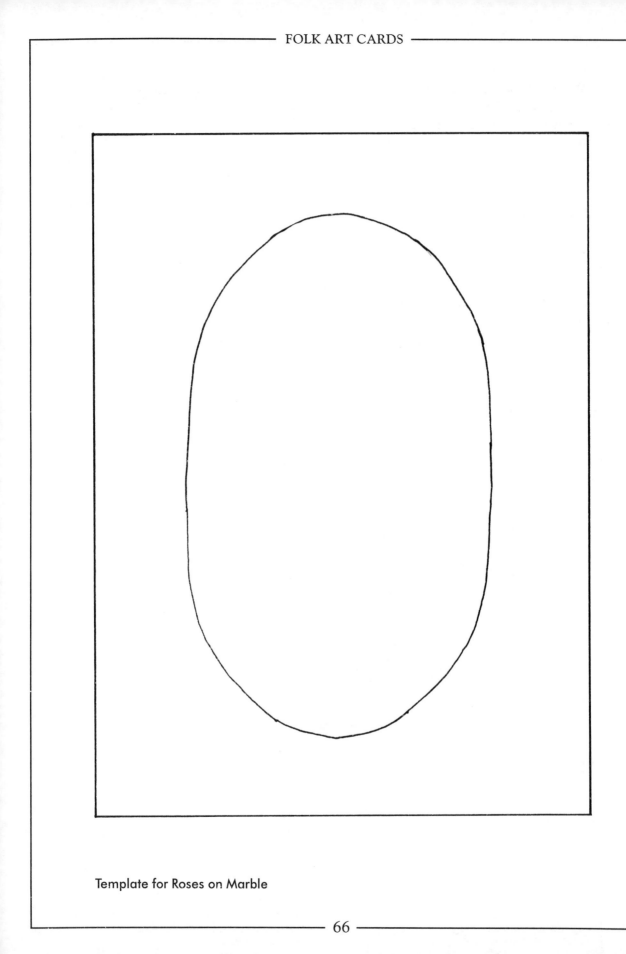

Template for Roses on Marble

Thoughts of Thee (Plate 6)

TECHNIQUES

Gold leaf. Antiquing. Washes. Pen and Wash.

COLOURS

Dioxin Purple. Yellow Light. Pine Green. Rich Gold. Raw Umber Trans Magenta. Ultramarine Blue. Indian Red Oxide. Warm White.

METHOD

Cut out shape. Trace outline onto card. Paint two coats of Indian Red Oxide around border. Apply adhesive and apply gold leaf. A few hairline cracks of the Red Oxide showing through is good. Apply a thin wash of Dioxin Purple in centre space. Apply two coats of clear glazing medium. When dry, apply an antiquing mix of Raw Umber and a little retarder medium. Remove gently. Allow to dry thoroughly, then trace design using white Saral paper on to the card and outline the design with a fine black pen. Dry. Apply thin washes over pansies and leaves; the area towards the centres should be darker. Paint filler flowers with Magenta and Warm White, and Ultramarine and Warm White, Yellow Light and Warm White. Draw in some little squiggles with the pen.

FINAL TOUCH

Using pen, outline again. A little wash of Rich Gold here and there on the leaves looks good. Paint centres with Yellow Light.

MESSAGE

Pansies mean 'thoughts'. Is there a special person in your life to whom you would send this card? I hope so.

ENVELOPE

Purple, with gold writing and some painted gold pansies outlined with the fine-point pen would look wonderful.

To Jodie from Jennifer

With fondest love
Today I greet you
And hope that joy
Will ever meet you.

Anon.

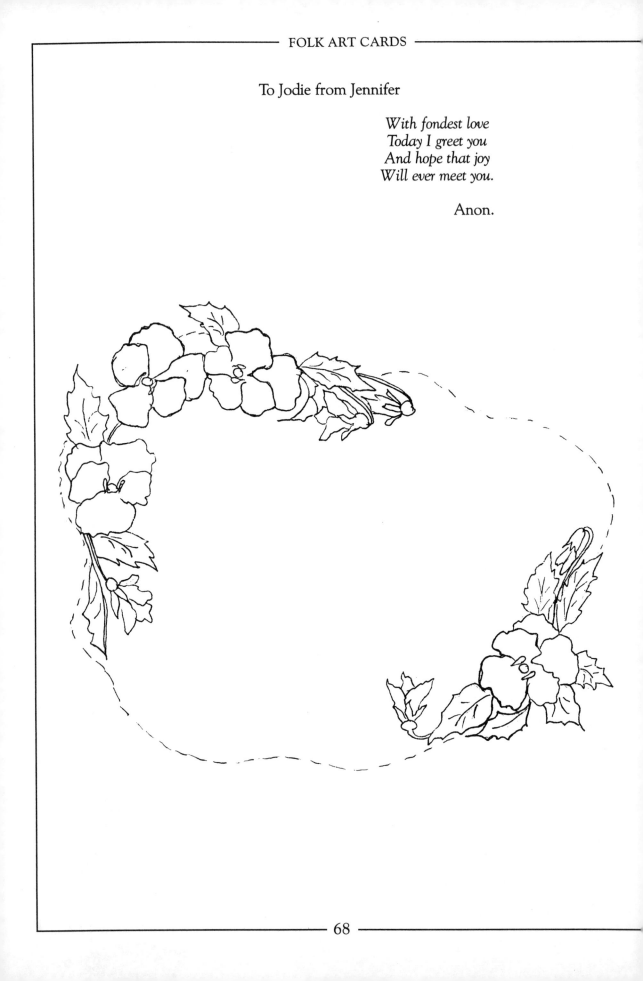

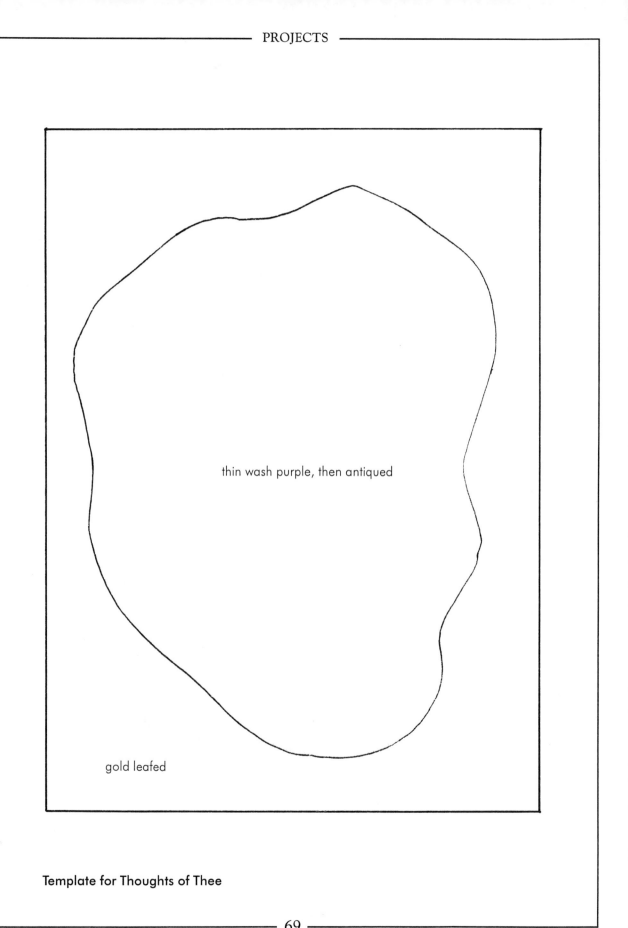

thin wash purple, then antiqued

gold leafed

Template for Thoughts of Thee

Small Gift Cards and Tags
(Cover and Plate 6)

As I have mentioned throughout the book, when you have some spare paint on your palette, it is a good idea to sponge some spare cards. The watercolour paper is very resilient and can be painted over again if you are not quite happy with the result. This happens when we first begin to paint, but as time goes by and we obtain better results, the discard rate is less. All painted paper is useful.

Patterns are included for some unusual-shaped tags. A small hole punch is useful for the tags, and small bunches of fine ribbons and metallic ties look lovely.

Lace, cord, dainty braids and tassels glued on make your cards so different from the ordinary purchased ones. Not only will your cards and envelopes be collectibles, but your gift cards and tags will be, too. For a good crease in a folded card, run the handle of a pair of scissors along the fold.

Most cards are quickly painted with the LAFS. See colour plates.

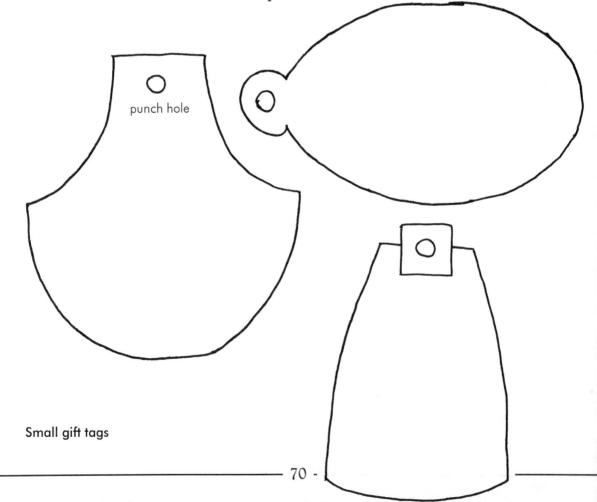

punch hole

Small gift tags

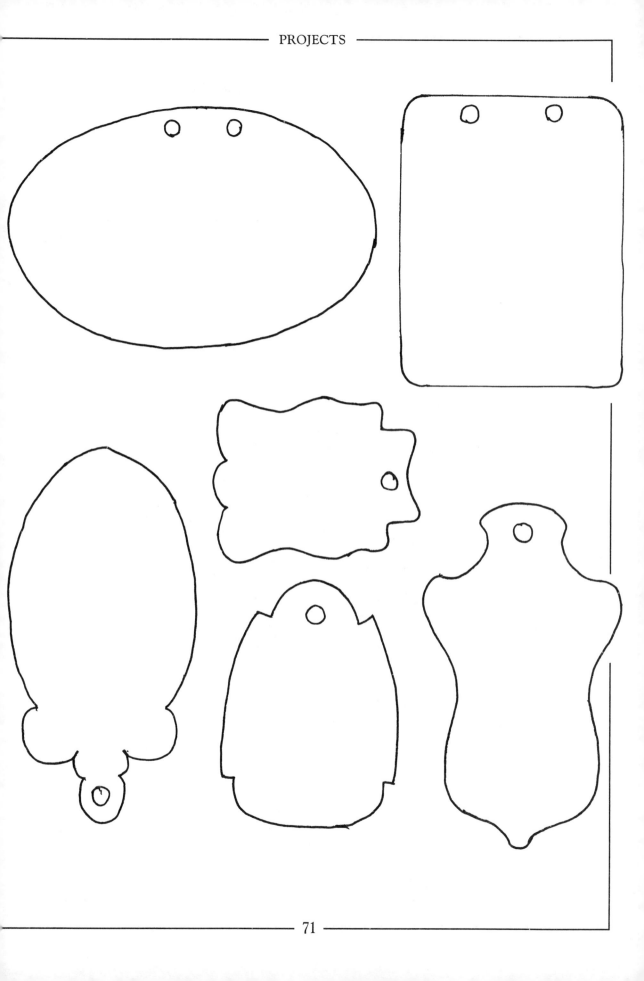

Chinese Cloisonné (Plate 7)

TECHNIQUES

Pen and wash.

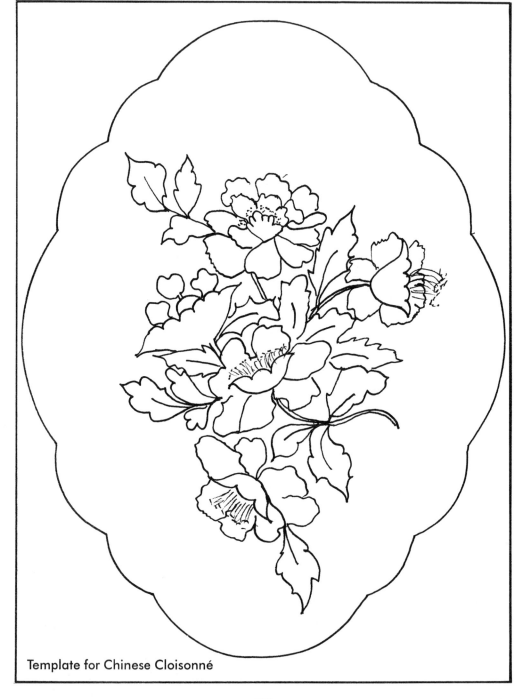

Template for Chinese Cloisonné

BASECOAT

Pale Gold. Blue Sapphire Metallic (FolkArt).

COLOURS

Yellow Oxide. Gold Oxide. Yellow Light. Sapphire. Ultramarine Blue. Storm Blue. Rich and Pale Gold. Moss Green. Green Oxide. Pine Green. Burgundy. Napthol Crimson. Napthol Red Light.

METHOD

Trace template shape onto card using blue Saral paper. Paint two coats of Blue Sapphire metallic paint on outside border. Trace design onto centre using blue Saral paper. Paint two coats of Pale Gold over centre shape. With a stylus or toothpick, make a pattern with dots of Rich Gold all over the card, except inside the design area. This resembles the copper wire shape where the enamel powders are placed. Outline with black pen. The colour changes of light, medium and dark must be quite definite on the petals and leaves. This is typical of the enamelling on Cloisonné ware made in China and Japan. Gradations of colour are also used in embroidery throughout many countries of the world, again to show shadow, light and highlight.

FINAL TOUCH

Rich Gold dots on the Pale Gold border.

MESSAGE

Personal note written on the back.

ENVELOPE

Blue with gold border. Write with a gold pen. Trace and paint some more flowers in the three colours.

With time and patience,
the mulberry leaf becomes a silk gown

An old Chinese proverb

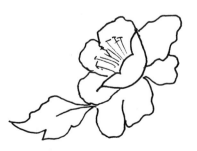

Happy Birthday, Daisy (Plate 7)

TECHNIQUES

Sponging. LAFS.

COLOURS

Norwegian Orange. Pearl White. Tapioca. Warm White. Moss Green. Pine Green. Jade. Brown Earth.

METHOD

Paint whole card with mix of Norwegian Orange and Pearl White. Cut template, sponge inner shape lightly with a thin mix of Tapioca. We want some background colour to show through.

Paint LAFS around edge of sponging. Paint small leaves with dagger and liner brush, all very washy. For painting daisies and buds, refer to the colour guide.

CENTRES

Moss Green dots.

BORDER

Small white strokes with liner brush, Moss Green dots and bows in corner with some Brown Earth filler leaves. Small Warm White gradations of dots are a very good 'filler'. Little gaps in our work can be filled with dots and 'filler' flowers described in 'M' *for Margaret*.

MESSAGE

Trace 'Happy Birthday'. With fine liner brush and two shades of green, paint one coat of green and another coat on here and there to create light and shadow on the letters.

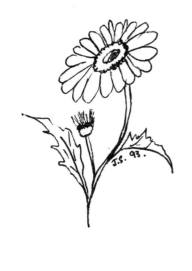

ENVELOPE

A natural-colour paper, with a large flap on which some sponging or spatters of leftover paint complement the card.

I really think that all the daisies deserve a mention. They are used over and over again in folk art and are lovely and colourful in the garden. Remember, "He loves me, he loves me not'?

Of course, he always loved us because daisies have an odd number of petals, and, if you started with 'he loves me', you had no problems.

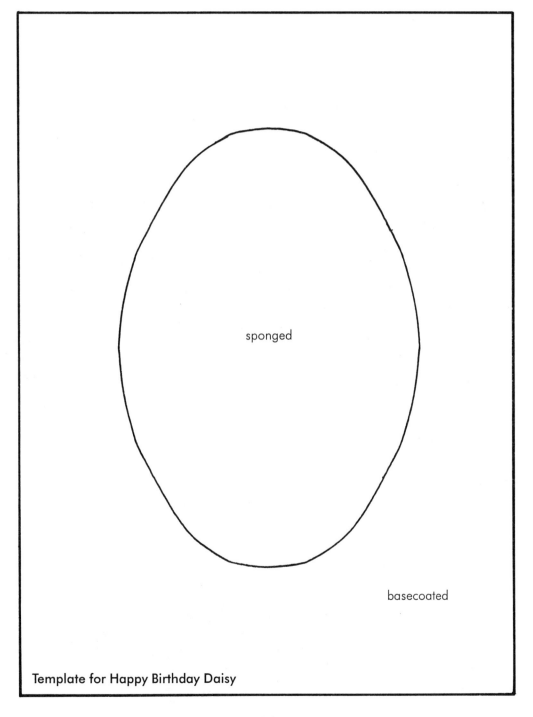

sponged

basecoated

Template for Happy Birthday Daisy

Simply Stroked (Plate 8)

TECHNIQUES
Kleistering. Wash. Double-loaded strokes.

BASECOAT
Sapphire.

COLOURS
Warm White. Norwegian Orange. Rich Gold. Green Oxide. Sapphire. Ultramarine Blue.

METHOD
Mix Kleister medium with small amount of Warm White and some water on a dinner plate; we want a thin mix. Put your hand into a plastic bag, pick up a little mix and pat off onto a paper towel. Place this gently on the surface of the card. We only want to apply a misty effect. Apply design and paint to colour guide. This is good practice for double-loaded strokes on the leaves, starting at the top and painting down. The flowers are basecoated with a mix of Norwegian Orange and Warm White. Save some of the mix for centres. When painting is complete, apply a wash of Ultramarine Blue around inner areas of the design to give the effect of shading.

FINAL TOUCH
Bow of Norwegian Orange and Warm White mix with Rich Gold. Centres are dots.

MESSAGE

Personal letter on the back. I wrote to a friend recently on a card like this. She had just become a grandmother for the first time. I was describing the joys this brings to us, and that we could be as dotty as we like and yet they still loved us.

ENVELOPE

Pale blue with a lovely small bow.

Grandmothers are antique little girls

Shimmering Doilies (Plate 8)

TECHNIQUES

Kleistering with paper doilies. LAFS.

BASECOAT

Pearl White two coats. Clear Glazing medium, two coats.

COLOURS

Pearl White. Ultramarine Blue. Rich Gold. Warm White.

METHOD

Apply basecoat and clear glazing medium. Dry. Mix Kleister medium and Ultramarine Blue to a thick paste and apply. Tear off circular borders of doily and press, right side down, onto mixture. Remove. Repeat process over another area. (See illustration, which shows a rose border.) With LAFS, paint blue and white roses. Refer colour guide. Pearl White gives a lovely shimmering effect through the Ultramarine Blue.

MESSAGE

I thought this card would be suitable for a special bridal gift wrapped in blue or gold paper. A hole punched in the corner, with lots of very fine ribbons tied on, trailing down over the gift.

ENVELOPE

Not needed. The card could be basecoated blue or gold on the back.

Paper doilies, to my surprise, come in many different patterns and sizes. When looking for the rose pattern, I also discovered clover leaf, daisy and paisley designs. For this, we have Mr Doily to thank. He was a London draper who created these lacy papers.

Cover

The cards and envelopes photographed and illustrated on the cover were all done in my style of painting which I have named LAFS, or Light Airy Fairy Style (see page 62). It is a free painting technique made up of trails, dagger brush leaves, small filler flowers, daisies, bows, buds and roses.

TECHNIQUES

Washes. Flat brush blending. Liner work.

BASECOAT

Pearl White. Blue Sapphire Metallic (Folk Art).

COLOURS

Blue Sapphire Metallic. Warm White. Pearl White. Rich Gold. Pale Gold. Ultramarine Blue.

ENVELOPES

The dark blue envelope was made with Canson paper with small bow, trails and leaves using the colours painted on the card.

The white envelope was painted with the same washes and LAFS as used on the front of the card.

GIFT CARD

The 'Thank You' card was painted with a light blue wash border and the LAFS. The message was painted with a liner brush. Refer to *Gift Cards and Tags* for instructions (see page 70).

Thank-You

K.A.

GIFT TAGS

For these small gift tags, I painted a whole card with the LAFS, then traced the template of the shape onto it. Cut out carefully. Punch a hole. Glue on braid, ribbons or metallic cord. Please refer to *Gift Cards and Tags* (see page 70).

Address Book

This address book was purchased, then given two coats of clear glazing medium. A trail of LAFS was painted in the same colours as the Cover card. 'Addresses' was already printed in gold on the cover, so it was a matter of painting on the left corner and sides.

When dry, apply two coats of clear glazing medium and allow to dry. The book was then quite heavily antiqued with a mix of retarder and Raw Umber. Please refer to *Antiquing* instructions on page 31.

I also held the book tightly shut and rubbed a little of this mix along the pages to age them.

When completely dry, a coat of clear glazing medium was applied over the surface.

These address books are inexpensive and come in all sizes. These, too, will become collectibles and make very unusual gifts, esecially when accompanied by a matching envelope or gift card.